POSTCARD HISTORY SERIES

Hopkinsville

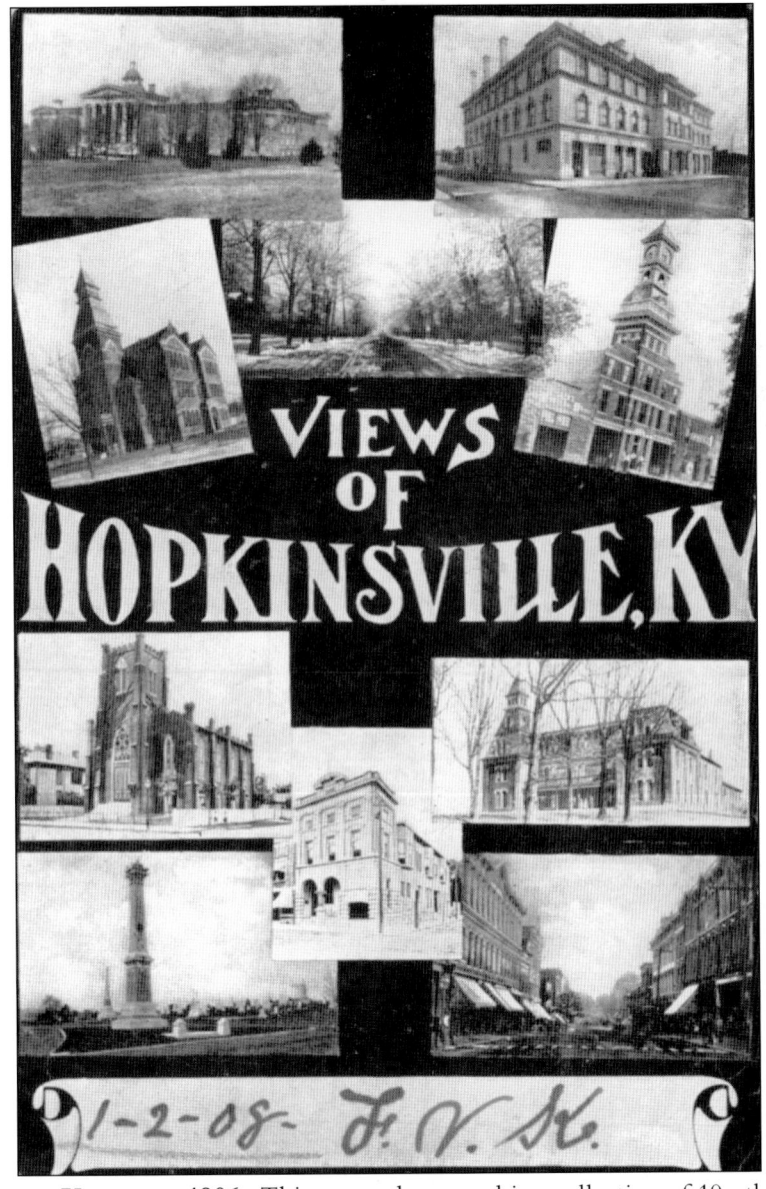

HOPKINSVILLE VIEWS, C. 1906. This unusual postcard is a collection of 10 other postcards, each one featured in this book. It was mailed to Sandy Creek, New York, in January 1908 and features, from left to right and top to bottom, Western State Hospital, Hotel Latham, Clay Street School, South Main Street from Fifteenth Street, Central Fire Station, Presbyterian Church, First National Bank, South Kentucky College, Confederate Monument, and a view of South Main Street from Seventh Street.

ON THE FRONT COVER: Advertising signs, vintage cars, parking meters, two-way traffic, familiar buildings, and much pedestrian traffic are visible in this view of Hopkinsville's downtown community as it was nearly 60 years ago.

ON THE BACK COVER: This large-letter postcard illustrates a generic collection of personalities in the word "greetings" and shows a number of familiar landmarks on the letters forming the name "Hopkinsville."

Hopkinsville

To Bill Holland

William T. Turner and Donna K. Stone

William T. Turner

ARCADIA
PUBLISHING

Published by Arcadia Publishing
Charleston SC, Chicago IL, Portsmouth NH, San Francisco CA

Printed in the United States of America

Library of Congress Catalog Card Number: 2006928115

For all general information contact Arcadia Publishing at:
Telephone 843-853-2070
Fax 843-853-0044
E-mail sales@arcadiapublishing.com
For customer service and orders:
Toll-Free 1-888-313-2665

Visit us on the Internet at www.arcadiapublishing.com

In memory of our mothers:
Virginia Major Turner Camp (1906–2004)
and Myrna Stevens Stone (1941–2005)

CONTENTS

ACKNOWLEDGMENTS

We would like to thank the following for their help and inspiration in the compiling of this book: Richard V. Williamson, Chris Gilkey, LaDonna Dixon Anderson, Billyfrank Morrison, Ben S. Wood III, D. D. Cayce III, Charles R. Jackson, Janet Bravard, James T. Killebrew, Christian County Historical Society, Pennyroyal Area Museum, and Kendra Allen. We would especially like to acknowledge the late Miss Emily B. Perry. Her postcard album containing approximately 40 images of Hopkinsville between 1895 and 1920 served as the inspiration for coauthor William T. Turner to spend his lifetime collecting and preserving old community postcards and photographs.

CHRISTIAN COUNTY COURTHOUSE, C. 1870. This real-photo card depicts the earliest known image of the courthouse.

INTRODUCTION

Christian County and its county seat, Hopkinsville, are located in southwestern Kentucky, a part of the Pennyroyal region. The area draws its name from a branched annual plant in the mint family. Pioneer settlers found Pennyroyal growing in abundance throughout the area, and they bruised the leaves and stems for use as a mosquito and tick repellent. Around 125 years ago, the colloquial term "Pennyrile" came into common usage and has thus been adopted in everyday speech, becoming more generally accepted that the original pronunciation.

The county, the second largest in the state, was carved from Logan County by the Kentucky General Assembly in 1796 with actual organization on March 1, 1797. Originally the county included all land north of the Tennessee line, west of Logan County and the Green River, south of the Ohio River, and east of the Tennessee River. All of the present counties in this area were formed out of Christian between 1798 and 1860.

The first permanent settlement in the county was made by James Davis and John Montgomery, natives of Augusta County, Virginia. Around 1784, they brought their families by flatboat down the Ohio River and then up the Cumberland River to settle on Montgomery Creek. Montgomery was killed by Native Americans while making a survey in Lyon County. Until his death in March 1797, Davis and his family lived on the farm they had settled.

Across the two decades, following the arrival of Davis and Montgomery, settlement was concentrated in North Christian and was completed by 1810. This area afforded a greater abundance of fresh water, wild game, and timber for building and firewood.

The level, fertile land in South Christian was settled in the first quarter of the 19th century. Both sections of the county were fully settled by 1830, when the population reached 12,684.

Hopkinsville was settled about 1796 by a North Carolina couple, Bartholomew and Martha Ann Wood. "Bat" Wood selected an area abounding in wild game, an abundant water supply, and land suitable for farming. The founder built a cabin on the present northeast corner of Ninth and Virginia Streets and a few yards east of the "Rock Spring."

Christian Quarterly Court selected the present site of Hopkinsville for the county seat in November 1797. The court accepted Wood's offer to give five acres of land and a half interest in his spring. The following year, a log courthouse, jail, and a "stray pen" were built on the "publick square" facing Main Street. In April 1804, the Kentucky General Assembly renamed the settlement Hopkinsville in honor of Gen. Samuel Hopkins of Henderson County.

Much social advancement indicated the progressive nature of local people through the middle of the 19th century. Local private schools in operation by 1812 preceded public schools by almost 30 years. South Kentucky College, established in 1849, and Bethel Female College, organized five years later, provided formal higher education for young women.

Toll road construction was initiated in 1837, thus starting a highway-building network that eventually destroyed the isolation of country life. Western State Hospital, a mental treatment facility organized in 1848, created job opportunities and a deeper awareness of human needs and compassion.

Christian County people witnessed the removal of the Cherokee Indians from their home in Eastern Tennessee to the new Indian Territory, now Oklahoma, in 1838–1839.

Circuit riders established the Methodist Church in Hopkinsville about 1800; then Little River Baptist Church was constituted in 1804. Other denominations organized in Hopkinsville

included Presbyterian in 1813, Cumberland Presbyterian in 1825, Episcopal in 1831, and Christian in 1832. The first Universalist church organized west of the Allegheny Mountains in 1819 was located in Christian County.

From the first issue of the *Western Eagle* in January 1, 1813, through 136 years of the *Kentucky New Era*, 45 newspapers have been printed in Hopkinsville and Christian County, including 9 newspapers published by African Americans.

Support for the Confederacy was strong in the southern part of the county. Christian County was the home of a Union general, James S. Jackson, and birthplace of the Confederate president, Jefferson Davis.

Christian County made a rapid recovery after the War Between the States. The reasons for this recovery are reflected through the stable labor market, the innovative approaches of the farmers, and the survival of prewar wealth invested in the construction of turnpikes, railroads, schools, houses, warehouses, and flour mills.

Turnpike construction progressed actively during the 1870s with the freeing of these toll roads accomplished in 1901. Rural free delivery of mail arrived the same year. The first federal highway, constructed of loose gravel between 1923 and 1927, was U.S. Highway 41 North and South, known as the "Dixie Bee Line." In 1932, this highway, along with U.S. Highway 68 West, was the first concrete paved road in the county.

Railroad construction and operation in the late 1860s opened markets for agricultural and industrial products, in addition to providing convenient transportation. Railroad service was inaugurated in 1868.

The African American community experienced development through the organization of a school system in 1872, and many new churches were constituted. In 1885, the first African American person served on a grand jury. By 1898, the race had been represented in the political offices of coroner, jailer, constable, and pensioner.

The city of Hopkinsville progressed through many social and civic improvements during the postwar period. A public library was established in 1874, two years after the city school system was organized. A Commercial Club, followed by a board of trade and the Hopkinsville Business Men's Association, dates from 1888. These groups were forerunners of the present chamber of commerce, organized in 1921.

Utility service installation included a telephone exchange in 1887, electricity in 1892, a water system in 1896, and a city sewerage service in 1906. Leisure and recreational activities included the Hoptown Hoppers baseball team in the Kitty League (1903–1954); WFIW, the first radio station (1927–1933); and the opening of Ware's Crystal Swimming Pool and "tourist cabins" at East Seventh and Butler Road in 1922.

In 1913, Christian County obtained one of the first county agents in Kentucky. Farm activities included the formation of the Farm Club in 1920, 4-H Clubs in 1921, and the first Homemakers Club in 1924. Pennyrile Rural Electric Coop brought the convenience of all-electric homes and farm buildings in 1938.

Jennie Stuart Memorial Hospital was a gift to the community by Dr. Edward S. Stuart of Fairview in 1914. The federal government erected a veteran's hospital at Outwood in northwest Christian County in 1922.

Cultural advancements include a new public library and a historical museum, the community concert association, an expanded Western Kentucky State Fair, three radio stations, the military base at Fort Campbell, United Way, the Bassett Urban Renewal Area and the Riverfront Improvement Project, the Pennyrile Parkway, and Interstate 24.

Educational changes were reflected through the closing of Bethel College, the opening of Hopkinsville Community College, the merger of the city and county school systems, and the opening of University Height's Academy and Heritage Christian Academy.

Medical mileposts were revealed through the creation of Western State Hospital in 1848, the county health department in 1944, the mental health center in 1967, and the extensive enlargement of Jennie Stuart Medical Center.

One

DOWNTOWN MEMORIES

DOWNTOWN PARADE. The photographer for this street scene positioned his camera on the balcony of Holland's Opera House. The year was 1901, and the event was the Elks Carnival Street Parade. The scene is looking south on Main Street across the Ninth Street intersection with First National Bank on the right and the Planter's Hardware Company in the background.

A 17062 Main Street, Hopkinsville, Ky.

MAIN STREET. Sparse telephone poles and very little traffic punctuate this *c.* 1905 streetscape of downtown's Main Street. Cooper's Tobacco Warehouse (at left) faces the Hille flats. The Forbes Building beyond (on the right) housed the offices of the Forbes Manufacturing Company.

Main Street, looking South, Hopkinsville, Ky.

MAIN STREET, SOUTH. George O. Thompson built the Thompson block (at left) in 1884. The structure housed a variety of stores, including jewelry stores, drugstores, wallpaper stores, and bookstores. For a brief period, Edgar Cayce operated a photographic studio on the second floor. A fire destroyed this landmark on December 31, 1984. The sidewalk clock (at right) was an advertising feature of R. C. Hardwick Jewelry Store. Horse-drawn wagons create a scene of much activity.

Main Street, looking North, Hopkinsville, Ky.

MAIN STREET, NORTH. A few months before this postcard image was taken, a downtown flood sent water two feet deep into this intersection of Ninth and Main Streets. This north-looking view features Gish and Garner Drugstore (at left). Charles Store later occupied the space. Holland's Opera House stood directly across the street.

East 9th Street, Hopkinsville, Ky.

EAST NINTH STREET. One hundred years ago, horse-drawn wagons parked at the curb in this scene on Ninth Street looking east from Main Street. In the summertime, water wagons sprayed the rock streets daily, with each business owner paying a monthly fee for this service.

ROCK BRIDGE. Bridge builder William Hyde constructed the Rock Bridge over Little River on North Main Street near the south entrance of Riverside Cemetery in 1858. The one-lane stone structure became a well-known landmark before it was intentionally dynamited in 1907 for the construction of an iron bridge.

Bird's Eye View of Hopkinsville, Ky.

BIRD'S-EYE VIEW. In 1906, local postcard collectors began acquiring this view looking southeast across town from the courthouse cupola. Sweeping from left to right, the viewer observes the Central Fire Station, Ninth Street Christian Church, and the Odd Fellow's Building. Acme Mills and Elevator Company is located in the distance (right background).

MAIN STREET, ONE BUSY DAY. Storefront awnings, two-story brick business houses, and rock streets greeted shoppers in downtown Hopkinsville about 1906. The original card was color-tinted in green, an unusual treatment to Hopkinsville cards of that era.

TRADE DAY IN HOPTOWN. A large crowd gathered in what the chamber of commerce called the "Dimple of the Pennyroyal" on trade day in 1908 to swap pocketknives, marbles, and watch fobs, as well as to trade mules, beeswax, and food products. The group was assembled on Main Street looking north at the Ninth Street intersection.

C. R. CLARK AND COMPANY. A half century of Hopkinsville postcard collecting has revealed a number of real-photo cards, an actual photograph printed on postcard stock. C. R. Clark and Company operated the largest downtown grocery on Main Street about 1907. The convenience of grocery delivery by horse-drawn wagon was a very successful marketing feature.

FORBES BLACKSMITH SHOP. A lineup of employees, with several wearing aprons, appears in front of the shop on Virginia Street between Tenth and Eleventh Streets about 1910. The Forbes firm operated 22 retail businesses from wagon making and buggy repair to clothing, jewelry, and grocery stores.

CHRISTMAS AT NINTH AND MAIN STREETS. Local Christmas customs included the placing of large cedar Christmas trees at several downtown intersections. This 1927 scene, complete with decorations on the tree, casts a view north on Main from Ninth. Note the angled parking on both sides of the street, a logistic that caused many fender benders.

MAIN STREET, C. 1920. Several changes are evident in this street scene from another postcard taken 15 years earlier. Although the buildings remain the same, brick sidewalks have been replaced with concrete, and the rock streets have now been paved with asphalt. Parking meters, direction signal lights, and a maze of utility lines were to come later.

MAIN STREET LOOKING SOUTH. This scene from the late 1920s reveals a multitude of cars with their angled parking along Main Street south of Seventh Street. J. H. Anderson and Company Department Store and S. H. Kress 10¢ Store are located on the right with Kolb Jewelry Store, Taylor's Drug Store, and Planters Bank and Trust Company on the left.

MAIN STREET, 1935. A color-tinted postcard, looking south on Main across Seventh Street, features vintage cars of the 1930s and reveals a rather clean looking town with the missing utility lines. The concrete pyramid–mounted traffic signal light at Seventh and Main Streets provided the opportunity for many smashed fenders.

Main Street Looking North, Hopkinsville, Ky.

MAIN STREET LOOKING NORTH, C. 1946. This scene of post–World War II Hopkinsville portrays a busy downtown section. Montgomery Ward, Ferrell's Snappy Service, and E. P. Barnes Department Store were longtime anchors on the west side of Main Street with Kroger Grocery, Bill's Auto Store, and Cayce-Yost Hardware Store on the right. Most of the automobiles featured date from the prewar era.

17

NINTH AND MAIN DURING FLOOD. Floodwaters covered the intersection of Ninth and Main Streets on Valentine's Day 1947. Higgins Drug Store, located at the southeast corner of the intersection, used fishing boats to save their lower shelf merchandise from the rising water. Next door, the Frank Cayce Company placed their stock above the water line.

FLOOD OF 1947. Another Valentine's Day high-water shot was made from a rowboat at the intersection of Ninth Street and Bethel Street. The camera lens was pointed east with the Standard Oil Service Station and the back of Charles Store on the left, and the First City Bank and Trust Company, the Cherokee Building, and the Elks Lodge on the right.

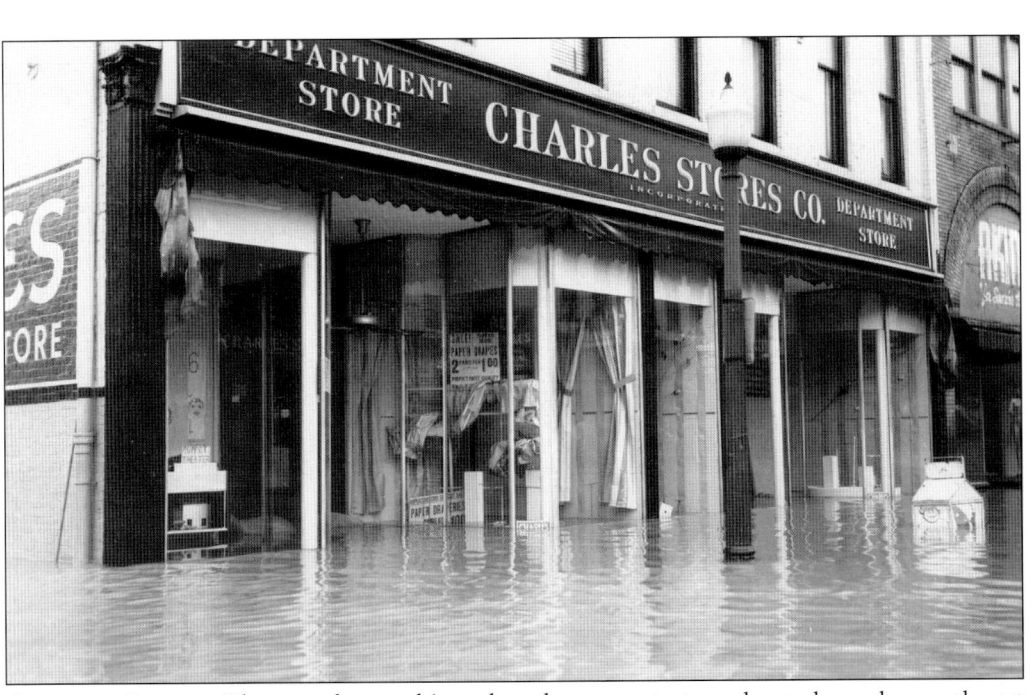

CHARLES STORE. The popular working-class department store, located on the northwest corner of Ninth and Main Streets, was underwater in the February 14, 1947, flood. This postcard is another example of a real-photo card.

STREET SCENE, C. 1948. Nearly 60 years ago, Main Street looking north from Tenth Street presented this view of downtown activity. The abundance of cars and many people on the street depict Hoptown in the pre-mall era. E. P. Barnes (at left) and Cayce-Yost Hardware (on right) were business anchors for over a half century.

Business Section Looking North, Hopkinsville, Kentucky

MAIN STREET. Downtown Hopkinsville witnessed many changes in businesses and signage over the half century between the earlier cards and what is presented in this 1956 image. Long familiar but now gone businesses include Blum's, Merit Shoes, F. W. Woolworth and Company, Keach's Furniture on the left, and Planters Bank and Trust Company, Jordan Furniture Company, WKOA Radio Station, and Little Chef restaurant on the right.

AERIAL VIEW. A camera view reveals this aerial scene of downtown Hopkinsville about 1958. Little River, Ragland-Potter Wholesale Grocery, and the Illinois Central Railroad yard form the boundary at left with Clay Street at right. Hopkinsville aerial view postcards are a scarce collector's item.

Two

TRANSPORTATION

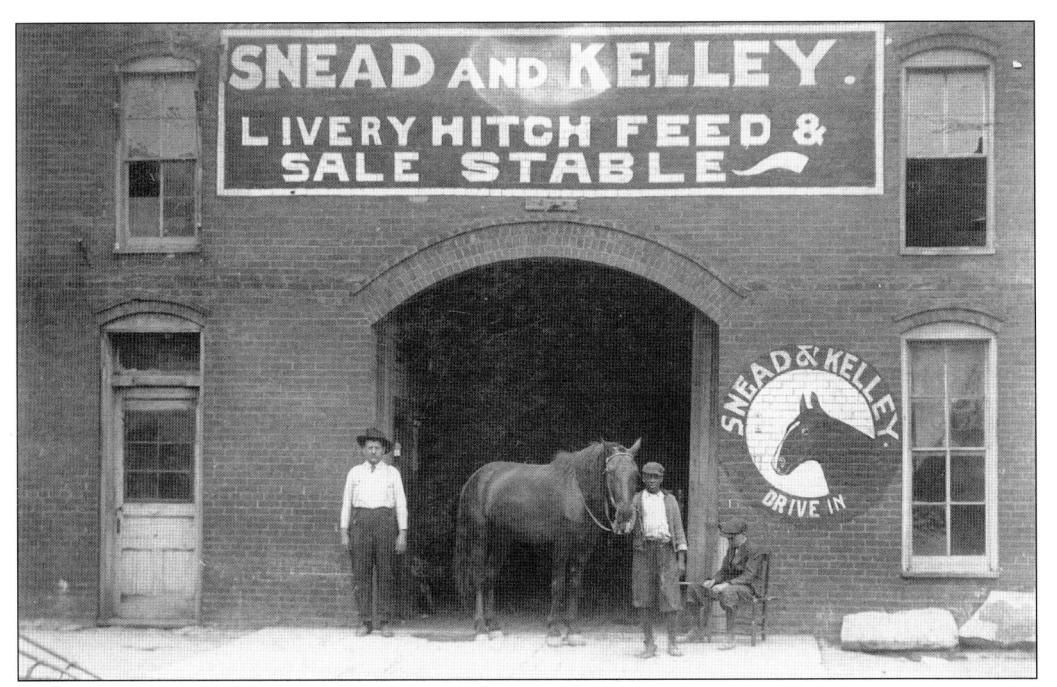

SNEAD AND KELLEY LIVERY STABLE. Livery stables were the automobile garages and service stations of the 19th century. This business, one of many in Hopkinsville, was located on the west side of North Main between Fourth and Fifth Streets. Renting service was provided for horses, mules, buggies, carriages, and sleighs. Boarding facilities and feed were also available.

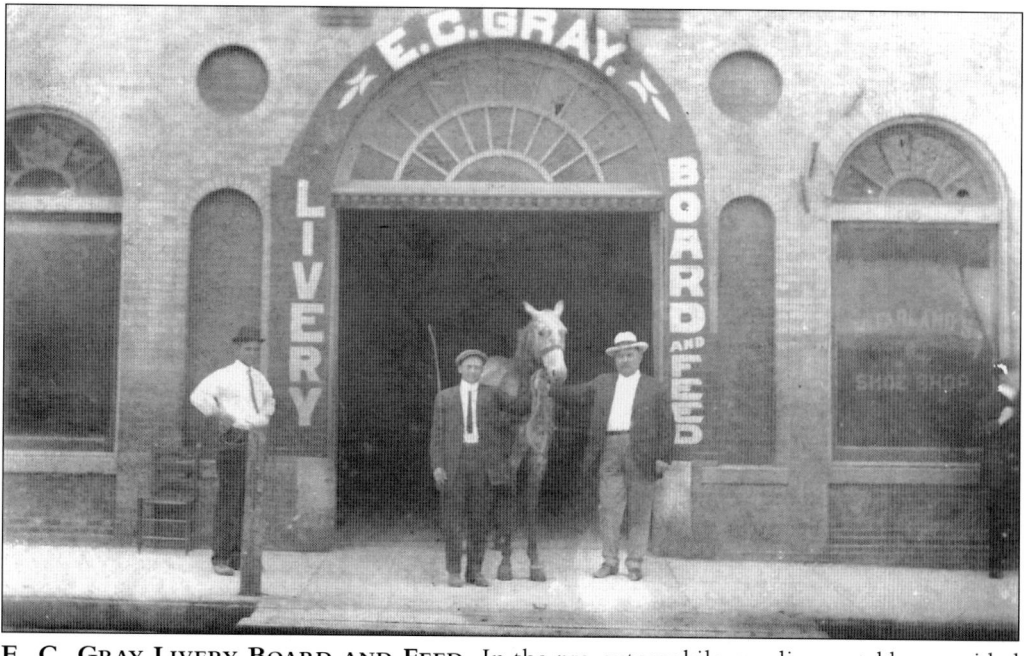

E. C. GRAY LIVERY BOARD AND FEED. In the pre-automobile era, livery stables provided the public with their transportation needs. Horses, mules, buggies, surreys, sleighs, and freight wagons could be rented by the day or the week. E. C. Gray operated this livery stable on East Ninth Street west of the Louisville and Nashville Railroad (L&N) passenger depot.

L&N RAILROAD FREIGHT DEPOT. In the 19th and first half of the 20th century, the vast majority of freight was hauled by rail. In 1905, the Dalton Brothers Brick Company built the Louisville and Nashville Railroad freight depot on Ninth Street. This site was occupied by the old Christian Male Academy from 1818 until it was destroyed by fire by Confederate forces in December 1864. The freight depot closed about 1968.

L&N STATION. The Night Riders, area farmers disturbed over the low retail price of tobacco, destroyed two independent warehouses on the lot in the foreground on December 7, 1907. That event opened this view of the passenger station, constructed in 1892, which was located on the site of its predecessor that had been destroyed by fire. The station (as pictured) was framed with weatherboarding. In 1909, the stucco surface was applied and a 280-foot-long trackside-covered shed was built and extended from Ninth to Eleventh Streets.

ALL ABOARD. On an April day in 1910, two young local men, John W. Venable (left) and Osborn Radford, pose in front of a 4-8-0 steam locomotive about to depart the Illinois Central Railroad (ICRR) Depot. Three railroads serviced Hopkinsville: the L&N, the Illinois Central, and the Tennessee Central. This station was constructed in 1892 and was torn down in 1942 after passenger service had been abandoned.

The Redpath Chautauqua Special Enroute from Chicago to Dixie Land 1913.

THE REDPATH CHAUTAUQUA. A crowd gathers at the Hopkinsville L&N depot to welcome the Redpath Chautauqua, a traveling performance group, who presented a show here in 1913. Lebkuecher's Band, a local musical group who provided entertainment for many years, greeted the performers.

L. & N. R. R. Station, Hopkinsville, Ky.—16

L&N RAILROAD STATION, C. 1920. The L&N Railroad passenger station, on East Ninth Street, was completed May 31, 1892, on the site of the depot, which burned November 5, 1891. The station was the scene of the Christmas Eve passenger train wreck in 1937. Passenger service ended in 1971. Restored in 1982–1983, the landmark is now the location of the Pennyroyal Arts Council offices.

I. C. Depot, Hopkinsville, Ky.

L. & N. Depot, Hopkinsville, Ky.

HOPKINSVILLE PASSENGER DEPOTS. This rare double-view card was printed about 1915. It shows the ICRR Passenger Depot (at top) where the passenger trains backed into the station and the L&N Passenger Depot where trains pulled along the side of the building.

CASKY STATION. Along the railroads throughout Christian County, a number of combination passenger-freight stations served the rural communities. Casky Station, located on the L&N Railroad, was constructed in 1868 and was torn down shortly after passenger service ceased in 1939.

"THE FACTORY THAT MAKES AND GUARANTEES THE MOGUL WAGON,
HOPKINSVILLE, KY."

MOGUL WAGON FACTORY. Brothers J. K and M. C. Forbes organized Hopkinsville's largest industrial complex in 1871. The company manufactured wagons of the following varieties: farm, log, mountain, platform spring, coal, and ice, as well as drays, floats, and gun carriages. Fire destroyed the plant located at Twenty-first and Harrison Streets on December 28, 1925.

THOMPSON AND PERKINS D-X SERVICE STATION. John P. Thompson Sr. and W. T. Perkins opened Hopkinsville's oldest automobile-related business in 1927. It is located on the southwest corner of Fourth and Main Streets and has been operated by the same family for nearly 80 years.

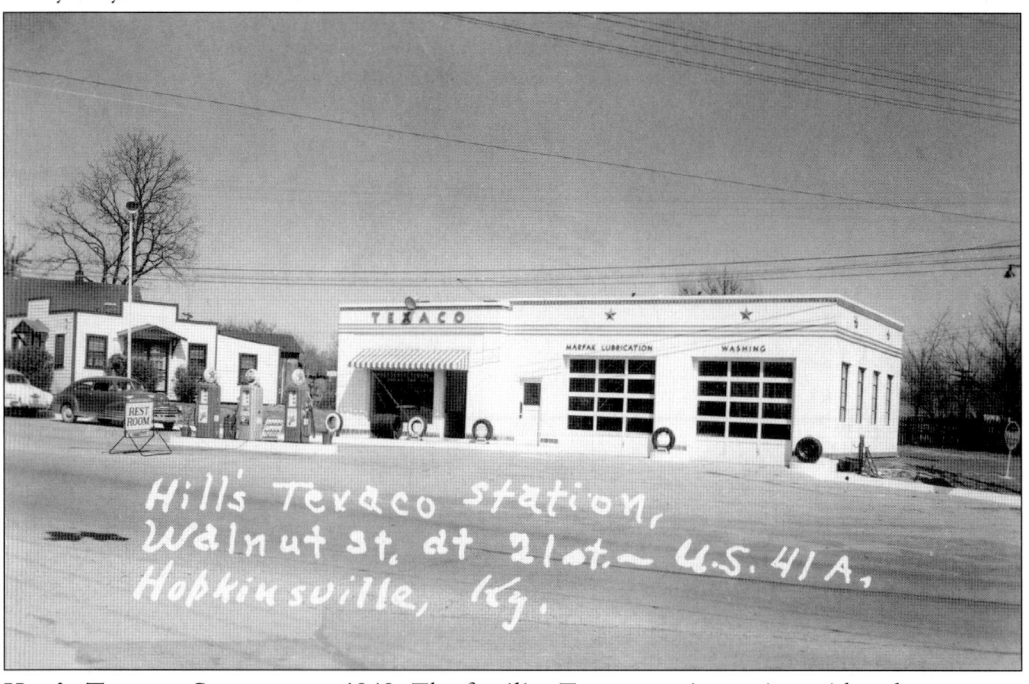

HILL'S TEXACO STATION, C. 1949. The familiar Texaco service station with red stars was a popular stop on U.S. Highway 41 A. Located at the corner of South Walnut and Twenty-first Streets, across from Hopkinsville Milling Company, this was one of several stations operated by the Hill brothers from the 1930s through the 1960s. The location was a major tourist stop on the main north-south highway through Hopkinsville before the construction of the Pennyrile Parkway.

WILLIAM'S USED CARS. Chevrolet dealerships have operated in Hopkinsville since 1918. M. G. Williams, then co-owner of Pierce and Williams Hatchery and Feed Store, opened this

dealership in 1954, and the family continued the operation until 1980. The used car lot was located on the west side of Clay Street between Fifth and Sixth Streets.

HOPKINSVILLE LINCOLN-MERCURY, INC. Fort Campbell Boulevard (U.S. Highway 41 A) was the scene of extensive business expansion after World War II. This automobile dealership opened in 1948. Horace "Woody" Woodring, a car salesman with the dealership, was General Patton's chauffeur in Europe. The general died from injuries sustained in an accident in which Woodring was the driver. The Colonial Restaurant occupied this space during the early 1960s. Scott Nissan is now located there.

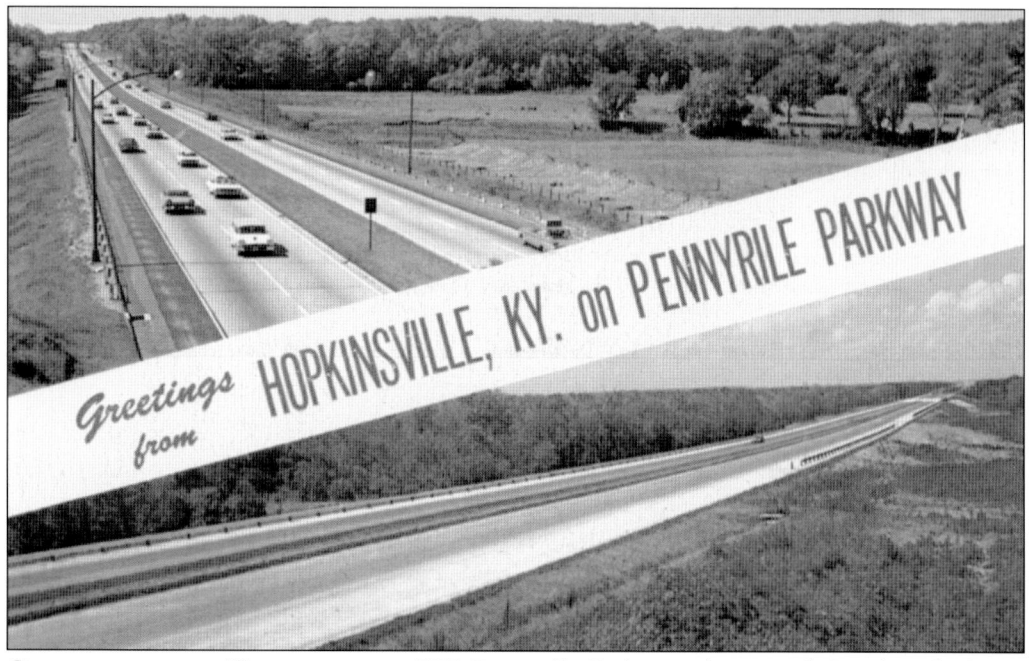

GREETINGS FROM HOPKINSVILLE, KY. Pennyrile Parkway, the second four-lane highway through Hopkinsville, was constructed between Hopkinsville and Henderson, Kentucky, in 1966–1969. It was one of the accomplishments made during the gubernatorial administration of Hopkinsville native Gov. Edward T. "Ned" Breathitt.

Three

PLACES OF WORSHIP

FIRST PRESBYTERIAN CHURCH. A Hopkinsville landmark, First Presbyterian, has stood on the southeast corner of Ninth and Liberty Streets for over 150 years. Constructed in 1849, the building was used as a hospital by Confederate forces in the War Between the States. The congregation divided in 1867, and the southern group occupied this structure until they were reunited in 1943.

First Presbyterian Church, Hopkinsville, Ky.

NORTHERN PRESBYTERIAN CHURCH. The southeast corner of Seventh and Liberty Streets was the site of the First Presbyterian Church of the northern group. Constructed in 1880, it was used until 1943, when the southern and northern groups reunited. The Salvation Army acquired the building, which was torn down in 1973.

A 17067 Union Tabernacle, Hopkinsville, Ky.

UNION TABERNACLE. The southeast corner of West Seventh Street and Cleveland Avenue was the site of Hopkinsville's first convention center. Methodist evangelist Sam Jones (of Atlanta) conducted four revival meetings in Hopkinsville. After the first meeting, conducted in a tobacco loose floor, Jones led the effort to construct, in 1893, a civic auditorium. The facility served as a gathering place for religious, political, civic, and social events. Neglect and floodwaters from the Little River led to its destruction in May 1941.

32

Methodist Church, Hopkinsville, Ky.

METHODIST CHURCH. The southwest corner of Ninth and Clay Streets was the site of Hopkinsville's second Methodist Church building. Constructed in 1848, the building originally featured a Greek Revival–boxed tower. In 1891, structural remodeling created these Gothic twin towers and a steeple. After this location was vacated in 1917, when the new South Main Street Church was occupied, the landmark was torn down in 1919 by its new owner, businessman Louis Ellis, who built an automobile dealership on the site.

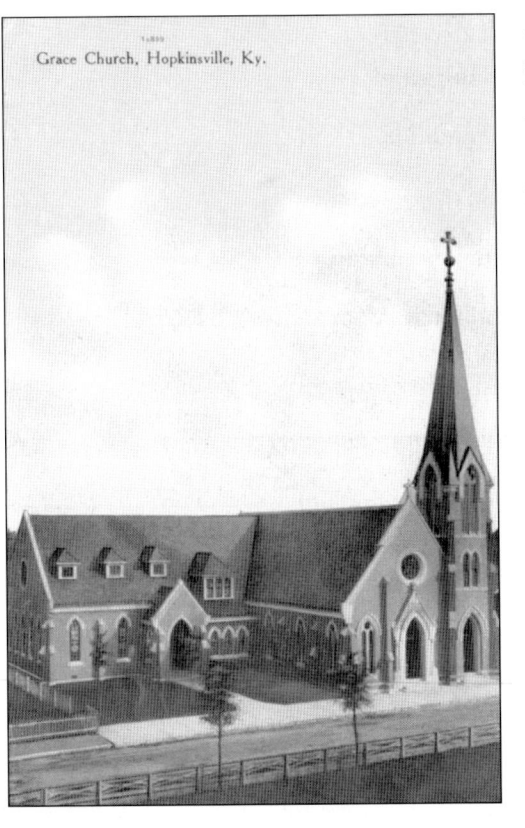

Grace Church, Hopkinsville, Ky.

GRACE EPISCOPAL CHURCH. This Gothic structure, at Sixth and Liberty Streets, was built in 1883–1884. J. Rosenplanter was the architect, and Robert Mills was the contractor. The first service was conducted in August 1884, and the church was consecrated in November 1890. The tornado of May 12, 1978, destroyed the tower and steeple. It was reconstructed the next year.

GRACE CHURCH INTERIOR. Christmastime at Grace Church presents a scene of roses decorating the altar. This church has been the scene of many happy occasions and somber moments.

Christian Church, Hopkinsville, Ky.

NINTH STREET CHRISTIAN CHURCH, C. 1900. This church occupied the northwest corner of Ninth and Liberty Streets. Constructed in 1850, it was used as a C.S.A. hospital during the War Between the States. South Kentucky College was organized here, and classes were conducted on the ground floor from 1849 to 1858. In 1854, it was the home church of Alexander Cross, the first slave liberated by the Christian Church in the Liberian movement. This nationwide movement led the effort to buy, free, and educate U.S. slaves for relocation to Liberia.

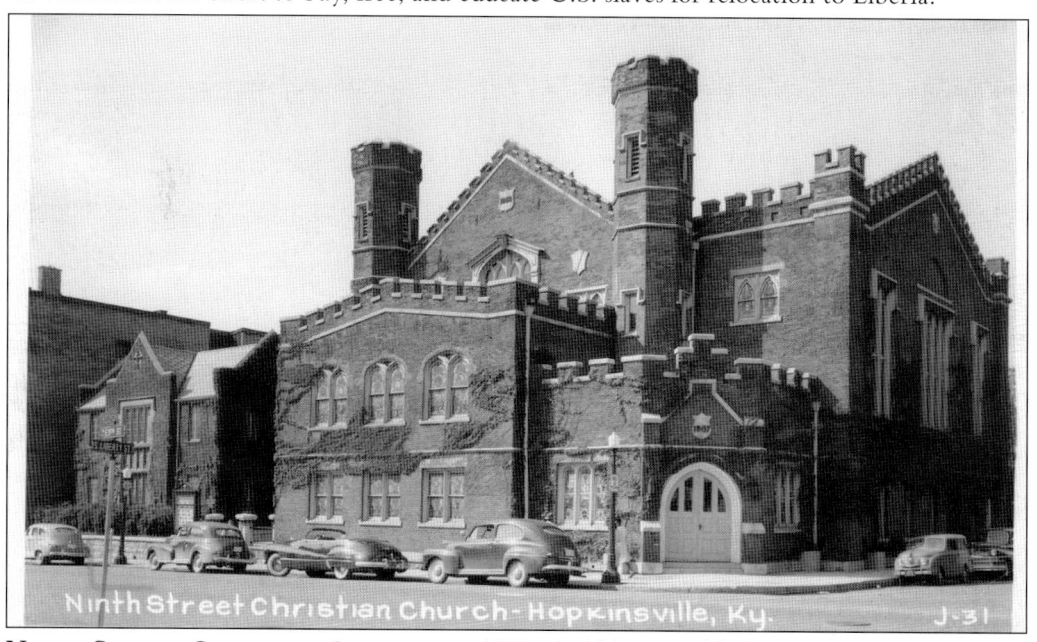

Ninth Street Christian Church - Hopkinsville, Ky. J-31

NINTH STREET CHRISTIAN CHURCH, C. 1950. At 100 years old, the Ninth Street Christian Church appears extensively changed in this scene. In 1907, the sanctuary was remodeled into the familiar, semicircular formation called the "Akron Plan" and a stucco finish was applied to the exterior. The educational building (left) was constructed in 1929. The church was torn down in 1958.

VIRGINIA STREET BAPTIST CHURCH

Organized 1850

Corner Third and Virginia Streets
HOPKINSVILLE, KENTUCKY

The Friendly Church for All Friendly People.

"Oh come, let us worship together and bow down: Let us kneel before the Lord, our Maker."—Psalm 95:6.

A. R. LASLEY, Pastor.

VIRGINIA STREET BAPTIST CHURCH. This African American congregation was organized out of the First Baptist Church about 1851. For 40 years, members worshipped in a brick structure on the northwest corner of Fourteenth and Virginia Streets. In 1892, the church pictured here was constructed on the northwest corner of Third and Virginia Streets.

RIVERSIDE CHAPEL. In 1916, the City of Hopkinsville constructed Riverside Chapel, which served as a convenient location for funerals through the 1930s. This facility was a public service for funerals since Hopkinsville did not have funeral homes in that era. J. T. Waller designed the Gothic structure. It was restored in 1960 and 1981.

FIRST BAPTIST CHURCH, C. 1948. Located on the southeast corner of South Main and Fourteenth Streets, First Baptist Church was dedicated on December 16, 1894. This Gothic structure cost $28,000 and was equipped with a water-powered pipe organ. It was also one of the first buildings in Hopkinsville with electricity. The steeple was removed in 1963. Tragically some members sought to replace the church, and the landmark was torn down on October 12, 1965.

FIRST BAPTIST CHURCH. In 1965, the congregation of First Baptist Church built a new facility on South Main Street at East Sixteenth Street. This structure is the fourth building in which the congregation has worshipped since its founding in 1818. It was remodeled in 2006 with the addition of an entry portico.

Methodist Church, Hopkinsville, Ky.

FIRST METHODIST CHURCH, C. 1948. The Methodist congregation was established in Hopkinsville around 1800. This building, the third occupied by the church, was built in 1916–1917 on the southwest corner of South Main and West Thirteenth Streets. The structure was twice gutted by fire, on March 12, 1931, and on February 16, 1948. It was rebuilt both times.

FIRST METHODIST INTERIOR. Beautiful stained-glass windows, massive roof supporting beams, and the majestic voice of the pipe organ all serve as physical reminders of the interior beauty of this nearly a century old church.

FREEMAN CHAPEL CME CHURCH. This African American Christian Methodist Episcopal church is located on the northwest corner of Second and Virginia Streets. Organized in 1866, the congregation worshipped for many years in a church at Eleventh and Liberty Streets. Named in honor of steward Peter Freeman, the church was constructed in 1923–1925.

SECOND BAPTIST CHURCH. This congregation was organized out of First Baptist Church in 1910. After meeting in a private home for several years, the old church was constructed in 1922 on the northeast corner of West Seventh Street and Kentucky Avenue. That building, now known as Duncan Chapel, was followed by the present church built in 1973.

CUMBERLAND PRESBYTERIAN CHURCH. In 1960, the congregation of Cumberland Presbyterian Church built this new facility on Fairview Drive. It replaced the 1883 downtown landmark church located on the south side of Seventh Street between Virginia and Liberty Streets.

CUMBERLAND PRESBYTERIAN CHURCH INTERIOR. A cross-accented stained-glass window, lantern lights, and exposed beams portray the modern look of church architecture a half century ago.

FIRST CHRISTIAN CHURCH. The congregation of Ninth Street Christian Church built this new facility in 1958. They moved to the Walnut Street and Morningside Drive location in 1959 and adopted the new name First Christian Church.

Four

EDUCATION

A 17064 South Ky. College, Hopkinsville, Ky.

SOUTH KENTUCKY COLLEGE. On February 24, 1849, a group from area Christian churches (Disciples of Christ) established South Kentucky College as a girls' school on Belmont Hill. It opened that fall and was in operation for nine years in the basement of Ninth Street Christian Church. The college became coeducational in 1881. The building pictured, the second on this site, was constructed in 1884.

FIRE AT SOUTH KENTUCKY COLLEGE. This is a view of the South Kentucky College (SKC) structure after fire destroyed the building on November 2, 1905.

SKC PENNANT. Miss Willie Rascoe, Wallonia, Kentucky, received this advertising card from South Kentucky College in March 1907. The message indicates that both the sender and the receiver were postcard collectors.

In image text:
MC LEON COLLEGE,
(OLD SOUTH)
KENTUCKY COLLEGE,
HOPKINSVILLE, KY.

MCLEAN COLLEGE (OLD SKC). This structure, built in 1906, was the third building on the site of the South Kentucky College. The school name was changed to McLean College on July 6, 1908, to honor Archibald McLean, president of the World Christian Missionary Society. This building burned February 2, 1912. The girls dormitory, Ella Jones Hall, was located at right.

YOUNG MEN AT MCLEAN COLLEGE. About 1910, this group of young men, probably members of the Philomathean Literary Society, assembled on the north lawn with the main college building in the background. Note the arrangement of their hats and caps in the formation of the letter M, signifying McLean College.

45

McLean College, Hopkinsville, Ky.

MCLEAN COLLEGE. This structure, built in 1912, was the fourth building on the site. McLean College operated for two more years before being absorbed by Transylvania College on January 21, 1914. The structure at left was McCarty Hall, the boys dormitory in the college days. It later became an apartment house. Today the college site is occupied by Belmont Elementary School.

Bethel Female College, Hopkinsville, Ky.

BETHEL FEMALE COLLEGE. Located on West Fifteenth Street, the college was organized as Bethel Female High School on March 9, 1854. The main building featured in this postcard was constructed in 1855–1857 and was built at a cost of $30,000. The name was changed to Bethel Female College in 1858, and it became Bethel Woman's College in 1917.

CONSTRUCTION AT BETHEL WOMAN'S COLLEGE. Hopkinsville saw the construction of a new west wing dormitory in 1919–1920 as the school launched an extensive building program into the mid-1920s. Excavation methods have changed greatly over the past 80 years.

BETHEL WOMAN'S COLLEGE.
HOPKINSVILLE, KY.—30

BETHEL WOMAN'S COLLEGE. The college assumed this new name by action of the board of trustees on June 4, 1917. Two dormitories, a dining room, kitchen, auditorium, and a swimming pool were all constructed between 1919 and 1925.

47

Bethel College, Hopkinsville, Ky.

BETHEL COLLEGE. In 1951, Bethel Woman's College became coeducational and "Woman's" was dropped from the name. A gala centennial celebration was observed in 1954. A new gym, now the Croft Office Building on South Main Street, was built in 1959. Bethel College marked its 110th year when it closed in May 1964. The historic Greek Revival structure was torn down in May 1966. The loss of this landmark sparked the motivation for the growth of historic preservation in the community.

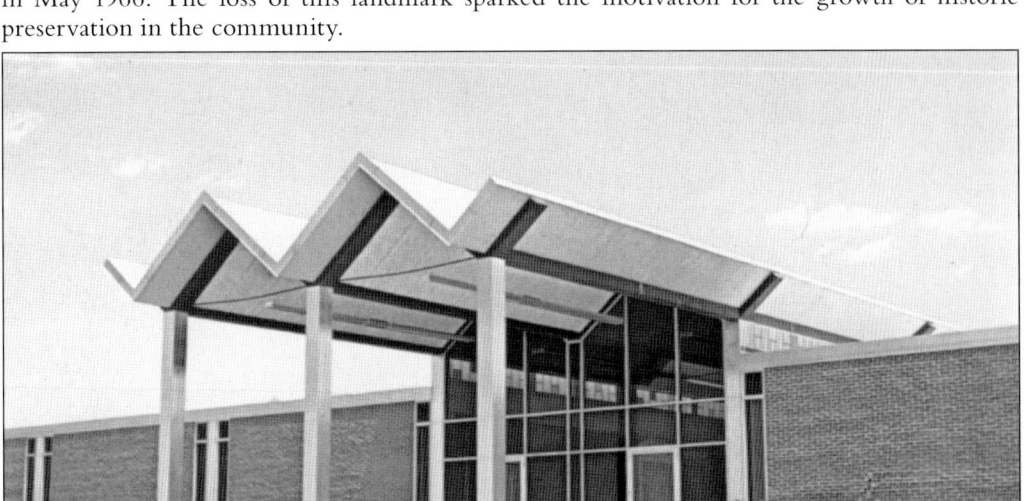

HOPKINSVILLE COMMUNITY COLLEGE. During the term of Kentucky governor and Hopkinsville native Edward T. "Ned" Breathitt, Hopkinsville Community College, located on North Drive, was established in 1962. Ground was broken for the academic building in September 1964, and the $909,000 structure was opened and dedicated in September 1965. Three hundred and thirty students were enrolled. Current enrollment, including the Fort Campbell branch, is about 3,100.

FERRELL'S HIGH SCHOOL. In 1873, the Christian County Male Institute was opened in this structure on West Thirteenth Street at Pioneer Cemetery. It operated under the name Hopkinsville High School from 1876 until 1899, and it was then known as Ferrell's High School until it closed in 1903. Confederate major James O. Ferrell managed the school. A Ferrell's Boys Reunion Association consisting of 638 boys conducted an annual reunion at Lake Tandy from 1915 through 1957.

HOPKINSVILLE PUBLIC SCHOOLS, C. 1914. Postcard publishers often included several scenes on one card. This card features West Side School (left), Clay Street School (center), and Virginia Street School (right).

Clay Street School, Hopkinsville, Ky.

CLAY STREET SCHOOL. This school was located on Clay Street between Fourth and Fifth Streets. It was constructed in 1880 at a cost of $13,000 and opened the next year as a 10-grade school. The 11th grade was added in 1892 and the 12th in 1903. The Hopkinsville High School name was adopted in 1904. This structure served as a grade school from 1912 until 1915, when the building was torn down and the materials used in the construction of Attucks High School.

VIRGINIA STREET GRADE SCHOOL. This school was built in 1901 on South Virginia Street between Nineteenth and Twentieth Streets. The $20,000 structure included eight large classrooms, a full basement, and a cafeteria located on the top floor. It originally served grades one through eight but was scaled down to grades one through six. The school was torn down in the fall of 1972.

WEST SIDE GRADE SCHOOL. This school was located on West Seventh Street at McPherson Avenue and was constructed in 1904–1905 at a cost of $19,000 to serve the children on the west side of town. The school closed in 1972, and it was torn down in the fall of 1974.

BELMONT GRADED SCHOOL HOPKINSVILLE KY.

BELMONT GRADE SCHOOL. This school was located on Belmont Hill, the old site of South Kentucky and McLean Colleges. Belmont Grade School opened here in the fall of 1915. The school was destroyed by fire on March 4, 1959. A new Belmont Elementary School stands on the hill today.

CHRISTIAN COUNTY AND HOPKINSVILLE HIGH SCHOOL, HOPKINSVILLE, KY.

HOPKINSVILLE HIGH SCHOOL. Construction for Hopkinsville High School, located on Walnut Street between Stanley Street and Central Avenue, began in 1910. It opened in 1912 and served the city's white high school students. A gym was constructed in 1930 and Tiger Stadium (now Walnut Street Stadium) was built in 1937. Hopkinsville High School relocated to Koffman Drive in September 1963. The landmark was torn down in 1976. A merger of county and city high schools, attempted in 1910, did not take place until 1971.

ATTUCKS COLORED HIGH SCHOOL, HOPKINSVILLE, KY.—20

ATTUCKS HIGH SCHOOL. In 1915, materials from the old Clay Street School were used to build Attucks High School. Attucks was constructed in 1916 on the northeast corner of First and Vine Streets to serve African American high school students. It closed in 1967 when desegregation moved the student body to Hopkinsville High School and Christian County High School.

Five

BUSINESS AND INDUSTRY

Cate's Mill, Hopkinsville, Ky.

CATE'S MILL, C. 1900. Water-powered gristmills represented the first local industry. Cate's Mill, situated on Little River at East Ninth Street, is one of the earliest mill sites in the county. The various owners applied their name to the business and thus it was known as (Preston) Gibson's, (James) Edward's, (Eugene) Wood's, and (Phil) Huffman's Mill throughout the 19th century. James and J. H. Cate owned and operated the mill from 1899 until it was struck by lightning and burned on September 2, 1918.

Hopkinsville Milling Co., Incorporated, Hopkinsville, Ky.

HOPKINSVILLE MILLING COMPANY. The second oldest business in the community, Hopkinsville Milling Company represents a merger of Climax Mill and the Crescent Milling Company in 1908. Their products, Sunflour Self-Rising Flour and Sunflour Self-Rising Corn Meal Mix, have become a community institution.

J. E. Green Tobacco Patch. Madisonville Pike. Hopkinsville, Ky.

TOBACCO, THE FIRST MONEY CROP. Dark tobacco, in contrast to burley, was the principal cash crop for local farmers from the settlement of the county until a quarter century ago. This rare postcard scene shows the tobacco patch of J. E. Green on the Madisonville Pike about 1905.

IN THE NIGHT RIDER DISTRICT OF KENTUCKY, TROOPERS GOING ON DUTY.

IN THE NIGHT RIDER DISTRICT OF KENTUCKY. The depressed retail market price for dark tobacco caused a farmers' revolt called the Night Rider Tobacco War. It was brought about by the monopoly created by James B. "Buck" Duke of the American Tobacco Company. The area affected included a 35-county region in west Kentucky and west Tennessee, called the "Black Patch." This rare card shows Kentucky State Guard Troops patrolling the Black Patch in 1908.

THIS IS MY DEVICE

THE PROTECTION OF THE LAW

"I'M GOING TO THE OPEN MARKET IN HOPKINSVILLE, THE BEST TOWN IN OLD KENTUCKY."

POSTER ADVERTISING OPEN MARKET. The Planter's Protective Association, in opposition to the Night Rider movement, distributed this poster throughout the area about 1910.

COOPER'S WAREHOUSE, SAMPLING GRADES. Tobacconist R. E. Cooper operated this tobacco factory on South Main Street between Tenth and Eleventh Streets. Here the tobacco was "prized" (packed) in large wooden barrels called "hogsheads" and then shipped by rail to tobacco processing factories. This warehouse burned in November 1927.

PLANTERS EXCLUSIVE BURLEY FLOOR. This view is from the northeast at T Street between Broad and College Streets and shows the new Planters loose floor. This term was derived from the loose stacking of hand-tied burley tobacco on a basket. The loose floor was built by J. E. Cooper about 1933 and was sold to W. B. Anderson Jr. about 1948. Anderson's three sons, W. B. III, Phelps, and Bobby Anderson, later owned the loose floor. It was destroyed by fire on December 7, 1981, and was rebuilt on the site.

PLANTERS BURLEY FLOOR, C. 1934. The production of tobacco, both dark and burley, has provided the backbone for the local economy since the days of settlement over two centuries ago. The raising of burley tobacco was introduced to Christian County about 1913. However, a local market, as portrayed in this postcard, did not open until about 1928. The Planters floor was located on the northeast corner of East Thirteenth and Broad Streets.

J. T. WALKER GROCER. Jake Walker operated this grocery store, located on the northeast corner of Fifth and Virginia Streets, for a number of years. This 1911 scene includes, from left to right, Herbert Grace, Gordon Walker, J. T. Walker, and John W. Overby. Customers handed an employee a grocery list, and the items were delivered to their home by a horse-drawn wagon.

PLANTERS BANK AND TRUST COMPANY. Hopkinsville's first financial institution, Christian Bank, was founded in 1818. Planters Bank was established in 1873 and was located in the old Christian Bank Building on the northwest corner of Fifth and Main Streets. A trust department was added in 1902 and the bank relocated to the northeast corner of Main and Eighth Streets. This advertising card, which featured the Westminster Chime Clock, was mailed to customers in the early 1920s.

Interior — PLANTERS BANK AND TRUST COMPANY, Hopkinsville, Ky.

PLANTERS BANK INTERIOR. This interior view reveals the remodeling completed to the bank lobby in 1956. The bank was located on the northeast corner of Main and Eighth Streets.

FIRST NATIONAL BANK. In 1888, local financial leaders organized the county's only national bank, originally located on the southeast corner of Ninth and Main Streets. Opening day at the new building, located on the southwest corner of Ninth and Main, was held in November 1902. The bank consolidated with City Bank and Company in June 1930 to form First-City Bank and Trust Company. The art deco front was installed at that time.

INTERIOR OF FIRST NATIONAL BANK. The new bank, on the southwest corner of Ninth and Main Streets, was featured in this postcard and was mailed to customers in November 1902.

W. H. COBB AND COMPANY SALOON. Fine whiskey and wines were sold in this saloon on East Sixth Street from 1912 to 1916. Cobb's was one of over 20 saloons located in Hopkinsville before national prohibition. Pictured from left to right are Clarence King, Wallace Cobb, Claude King, Hiley Cobb, unidentified, and Walter Cobb.

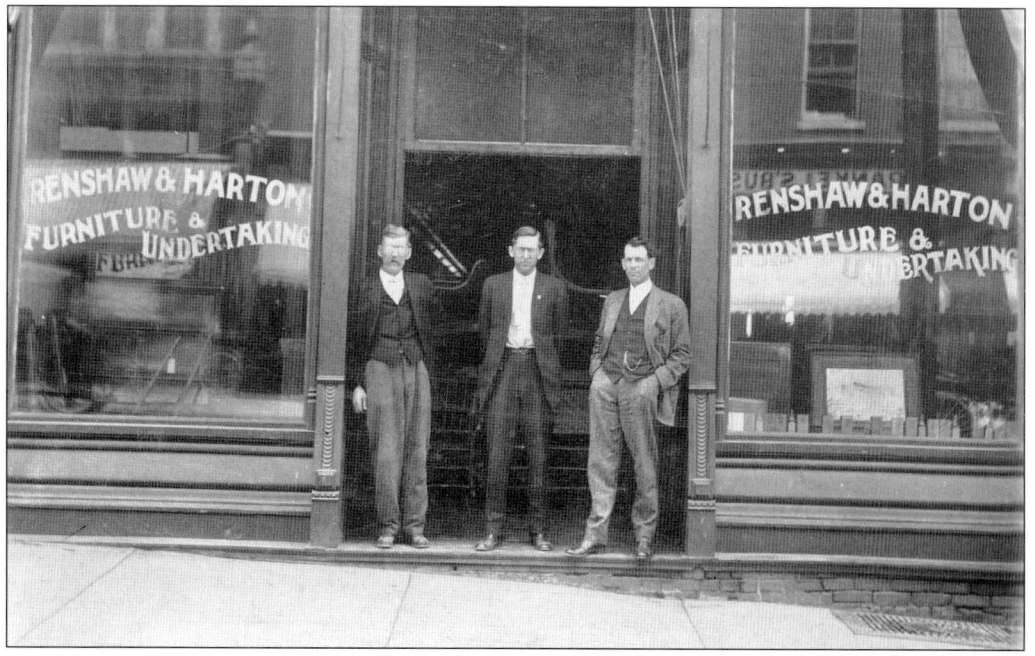

RENSHAW AND HARTON, C. 1912. The 19th-century retail furniture business also included a line of coffins. F. P. Renshaw and Harry L. Harton owned the Renshaw and Harton furniture store. It was located in the Thompson Building on South Main Street. Pictured from left to right are Jim Reese, John Reese, and Harry Harton.

CITY MARKET HOUSE. A crowd of African Americans has gathered at the City Market House, the grocery of C. R. Clark and Company. This real-photo card, made between 1903 and 1907, gives the location as the southeast corner of Eighth and Main Streets. Jordan Furniture Company was located at this corner from 1922 until *c.* 1973.

RAUBOLD BAKERY. Postmaster Joe Moseley (left) and Albert D. Noe Sr. (right), owner of Hotel Latham, appear in this real-photo card hitched up to the Raubold Bakery delivery wagon. The why of this connection is unknown.

PRINCESS THEATRE. This group of "Hoptown Dandies" poses in front of the Princess Theatre on East Ninth Street between Main and Virginia Streets around 1917. The Western Union office is located on the left, and George Duffer's Confectionary is at the right.

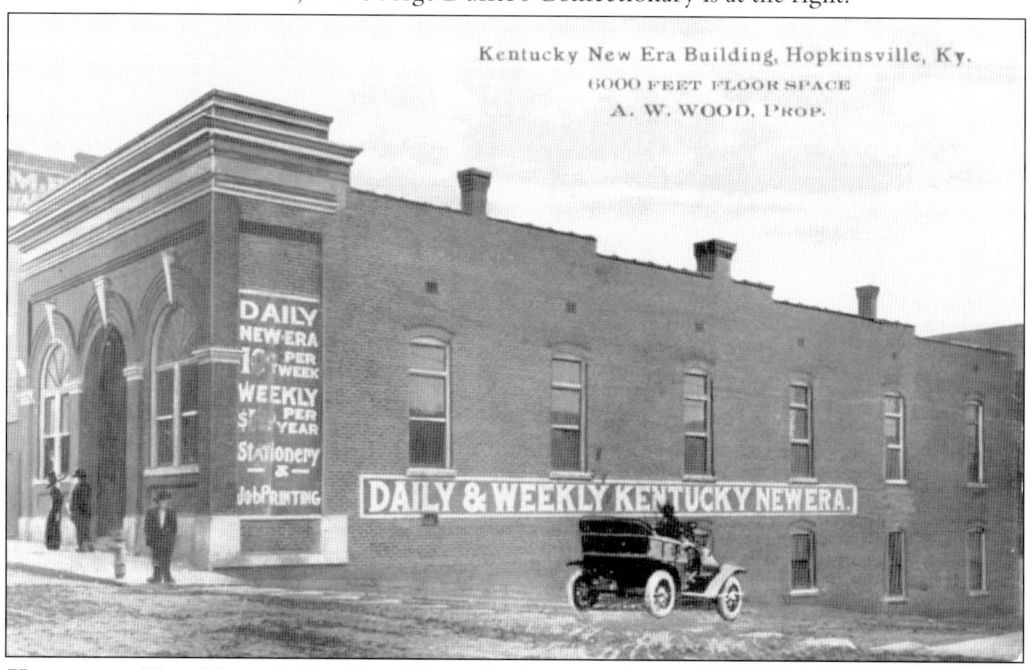

KENTUCKY NEW ERA. A Hopkinsville and Christian County institution, the *Kentucky New Era*, established in 1869, was located on the southeast corner of Seventh and Bethel Streets. The Wood family has owned the paper since 1873, and they constructed this modern printing plant in 1910. This card was published around that time. The plant moved from this location to Pembroke Road in April 1971.

GORDON CAYCE, INC. HOPKINSVILLE, KENTUCKY

GORDON CAYCE GIFTS. A Dutch carpenter, Dan Umbenhour, built this landmark for Robert Dillard in 1848–1849. It was the site of headquarters for both Union and Confederate forces during the War Between the States. Gordon Cayce, Inc., operated an antique and gift shop in the building from 1950 until 1982. It became the main office of Planters Bank in 1997.

GORDON CAYCE INTERIOR. Ellen Lucas and James Whitlock were longtime, faithful employees of Gordon Cayce Antiques and Gifts. They are shown arranging furnishings in the front display room, formerly the parlor of the old Dillard-Campbell-Green home.

63

MAPLE LAWN COURT — U. S. 41 — HOPKINSVILLE, KENTUCKY

MAPLE LAWN COURT. For several generations, from about 1938 until 1960, Maple Lawn Café and Modern Cabins was one of the most popular fast-food restaurants in Hopkinsville. E. W. and L. R. Woodburn managed the café and 12 cabins followed by A. J. Collins, Arnett Good, and Ted Alverson. The cabins featured steam heat and private showers. It was located on the west side of North Main Street at Maple Lawn Drive. Frozen Cokes, delivered by curb service, were a specialty.

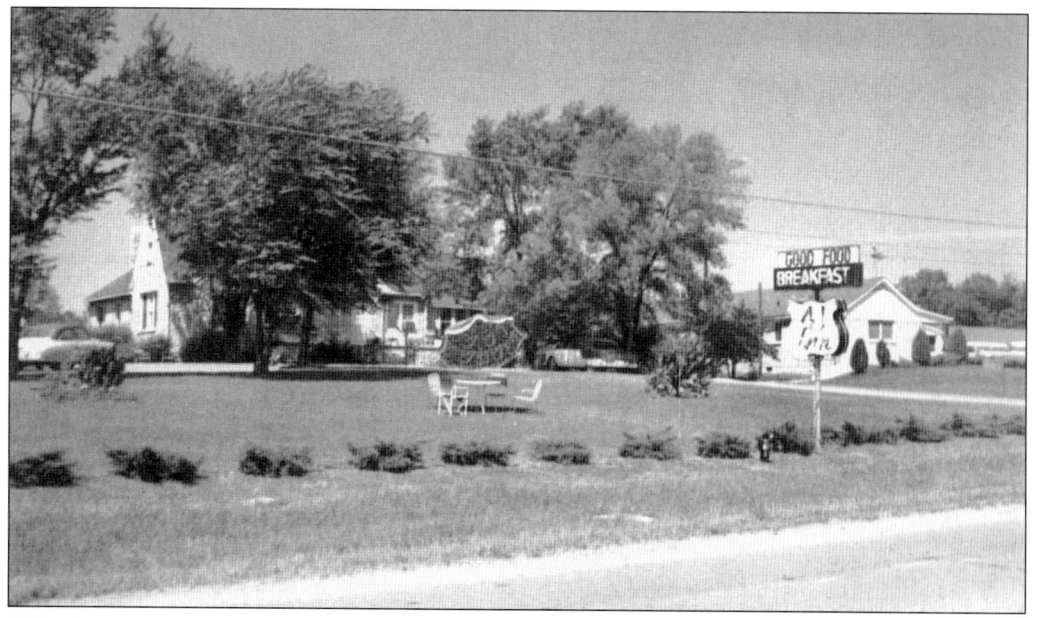

41 N RESTAURANT. Located on the west side of Madisonville Road (U.S. Highway 41 North), the restaurant originated as a stone house. Built by Buck Brame in 1935, it was occupied by that family for a number of years. It was converted into a restaurant by Hiram G. and Kate O. Kelly about 1954 and was operated by them until the late 1950s.

INDIANA CAFÉ. Located near Crofton on U.S. Highway 41 North, Indiana Tavern was a very popular eatery for tourists and locals alike. Jack and Erma "Ma" Bullock built this tavern in 1936 and operated the noted eating establishment and four tourist cabins out back. The restaurant burned on November 10, 1952. It was rebuilt and operated as Indiana Café until a second fire destroyed it in 1961. Rebuilt a third time, it burned again around 1968.

INDIANA CAFÉ INTERIOR. The specialty was Italian spaghetti with homemade sauce and garlic bread. Everyone liked the Italian chicken cooked in wine sauce. "Ma" Bullock was the first to serve steaks on a sizzling hot plate with a smorgasbord every Sunday. She became famous for her Italian dressing; its recipe is a guarded secret. The cocktail lounge was enjoyed on Saturday nights. Margaret Rash, at the Hammond organ, became a weekend favorite.

COLONIAL RESTAURANT. This building, which housed the Colonial Restaurant, was originally built about 1948 to accommodate the Hopkinsville Lincoln–Mercury automobile dealership. K. E. Bellm operated the Colonial Restaurant for a very brief period in the early 1960s. It is now the location of Scott Nissan on Fort Campbell Boulevard.

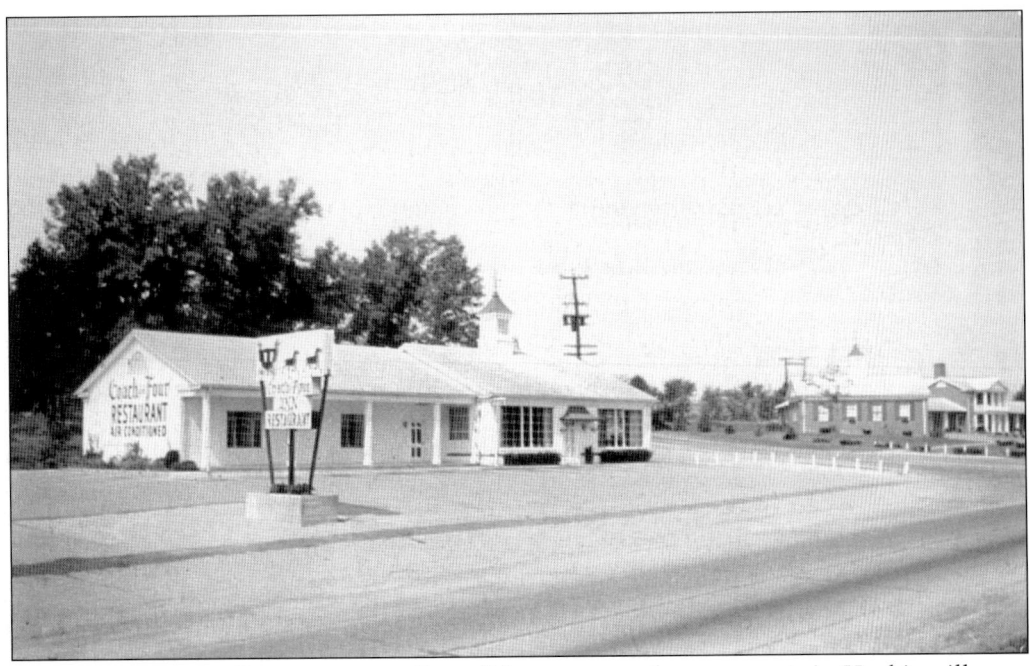

COACH AND FOUR RESTAURANT. One of the most popular restaurants in Hopkinsville was the Coach and Four. It was constructed and opened about 1953 on the southwest corner of Fort Campbell Boulevard and Country Club Lane. Operated by W. F. Dunning, W. R. Russell, and J. F. Ferrell, it was destroyed by fire about 1968.

Six

PEOPLE AND RESIDENCES

FOUR DUDES OUT FOR A RIDE. The year was about 1910 when four Hoptown friends went out for a spin. The make and model of the car is unknown, but the dapper-dressed fellows are (from left to right) Granville Cayce, John Moore Clardy, Robert Henry, and Osborne Radford. They are posed in a dummy automobile at Randall's Studio in Chester Park, Cincinnati.

JAMES H. QUARLES. This real–photo card is of James Henry Quarles. Quarles was a barber in Hopkinsville. He worked at a local barbershop from the 1890s until his death in 1916.

THE PRINCESS ORCHESTRA. In the days of silent movies, before the "talkie" came to the Princess Theatre in 1928, the Princess Orchestra entertained thousands and added a lighter touch to the silver screen. Members included (from left to right) Norman Syfers, Joe Day, and Robert Cooper.

NORMAN SYFERS JOE DAY ROBERT COOPER,

The Princess Orchestra

HOPTOWN HOPPERS. The Hoptown Hoppers posed in this Mercer Ball Park shot about 1910. The park was located in the West Ninth Street area, now occupied by the new Justice Center. Men in the picture include Bob Cook, J. T. Edmunds, Judge Walter Knight, and Clint Cayce. The others are unidentified.

COMPANY D BASEBALL TEAM. Company D of the Kentucky State Guard was known for years as the Latham Light Guards. They were activated for service on the Mexican border in 1916 and served in World War I. The team, managed by Lt. Cecil Armstrong (seated at far right), provided a great morale boost to the boys in uniform.

P. T. FRAZER JR., M.D. Patterson Tilford Frazer came to Hopkinsville at the age of 12 and attended Hopkinsville Male and Female College under the supervision of his uncle, Prof. P. T. Frazer. He entered Meharry College in Nashville, Tennessee, where he finished his medical training in 1913. Dr. Frazer practiced in Cadiz, Kentucky, until he volunteered as a medical examiner in World War I. At the end of the war, he came to Hopkinsville and resumed his practice of medicine and surgery. Dr. Frazer's office was located on Clay Street, and he also built and provided the Natatorium, a local swimming pool, for young African Americans in the 1930s. The back of this card states, "Healthful recreation and more than a good time awaits you at Frazer's Natatorium. You may get plenty to eat at all times from a Café on the Natatorium ground. The pool is 30x40 feet and equipped with bleachers to seat a hundred people."

THE GOAT MAN, C. 1940. The legendary "Goat Man," Charlie "Ches" McCartney (1901–1998), was an annual Hopkinsville visitor, usually in April, from about 1936 to 1959. In the days before television, he was a public spectacle. His dozen or so goats were hitched to a wagon that carried all of his possessions. When he arrived on the edge of town, people turned out like the circus had come. McCartney was a vagabond who loved to travel, and he entertained local residents with many tall tales. He bore every bad smell known to God or man.

L. D. MARTIN. Lester D. Martin (1891–1961) was a photographer and owner of Martin Studios for 34 years. He came to Hopkinsville in 1927. Martin was an avid fisherman at Lake Tandy.

"Chubby Dink" Embry. No person in the history of Hopkinsville was better known or more beloved than Drury Rathel "Chubby Dink" Embry (1920–1999). Embry came to Hopkinsville before World War II driving a 1937 Packard. He approached WHOP station manager Hecht Lackey about singing and telling jokes on the air. After service in World War II, he returned and awakened the community every morning for over 50 years on the *Early Bird Show.*

Goober and His Kentuckians. In the post–World War II days, before television, local radio performers were members of the family. Goober and his Kentuckian musicians included (from left to right) Chubby Dink, Cotton Carrier, Little Sister Lillie, Cousin Dixie Belle, Goober, and Bashful Bob. They were a highlight on local radio station WHOP.

THE KENTUCKIANS ON WHOP. From left to right are (seated) "Chubby Dink" Embry and Pete Scott; (standing) Joe Goodwin and Jimmy Ritter, who entertained enthusiastic listeners over the radio in the 1940s.

LITTLE THEATER, 1952. A regular feature of *Coffee Time* on radio station WHOP was the *Little Theater Off Trading Alley*. This program, sponsored by Frank Cayce Company, featured (from left to right) Leo Wilson, Bob McGaughey (who impersonated Judge Jonathan Hardrock), and Charles Stratton.

THE BLUE LANTERN. This grand landmark home was constructed between 1851 and 1854, in the Italianate style, by John Orr for Robertson T. Torian. The hallmark of the home is a handsome center stairway in the main hall. The Madison S. Major family owned the place from 1856 to 1903. Later Emmett Cayce operated the Blue Lantern Tea Room here in the 1930s. Ben S. Wood bought the farm in 1940, and Ben S. Wood III currently owns the home.

LATHAM HOMESTEAD, C. 1905. Thomas M. Buck had this home constructed in 1845. The lot upon which it was built comprised the entire area of present Virginia Park. The family of John C. Latham Sr. owned this landmark from 1856 until 1909. Upon the death of John C. Latham Jr. in 1909, the home was relocated to Alumni Avenue and the old homestead lot was developed into Virginia Park. The park was named for his mother, Virginia Glass Latham.

PERRY HOMESTEAD, C. 1907. The family of former Grace Episcopal Church rector Dr. Gideon B. Perry occupied this home (above) located on the southeast corner of Ninth and Campbell Streets from around 1877 to 1923. The landmark's most illustrious occupant was his daughter, Emily B. Perry. "Miss Em," as she was known, was a friend and inspirational supporter of young people. Miss Em engaged a local photographer to preserve an image of her Victorian parlor (below). The view, which she had printed as a real-photo card, features Miss Em (left) and Miss Mariah Efnor (right).

Main Street Looking South, Hopkinsville, Ky.

MAIN STREET LOOKING SOUTH. F. W. Woolworth and Company published this South Main Street view about 1914. The scene is looking south on Main at West Fifteenth Street and features (on the right) the historic brick home of Strother J. Hawkins and later Hiram A. Phelps.

East Seventh Street, Hopkinsville, Ky.

EAST SEVENTH STREET, C. 1915. East Seventh Street at the intersection of Campbell Street provides this view looking east with Virginia Park on the right and the George Dalton house on the left.

HOPPER COURT, C. 1905. The family of Elijah Harrison Hopper, the owners of a downtown stationery and bookstore, built the Hopper House in the 1860s. Later additions, including a mansard roof, were made in the 1880s. About 1910, real estate developer T. J. McReynolds sold lots and built homes on each side of the original carriageway. Later owners of the home included Dr. Austin Bell, Herman Lile, and Darrell Gustafson.

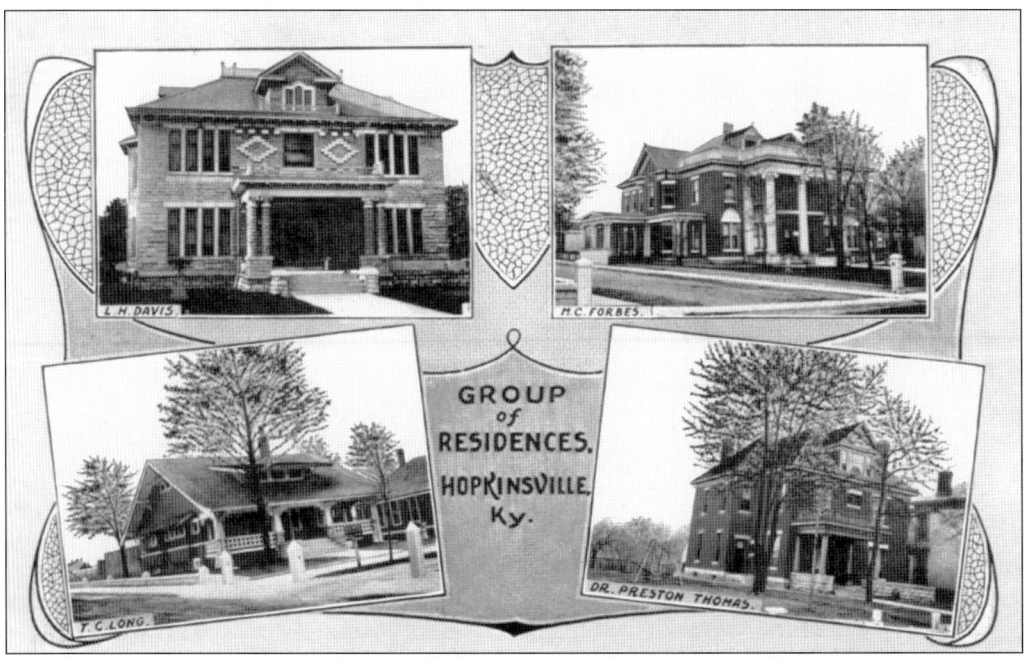

GROUP OF RESIDENCES, C. 1915. Prominent Hopkinsville families constructed a variety of styled homes in the first decade of the 20th century. These families included (from upper left and moving clockwise): Lucian H. Davis, J. K. and M. C. Forbes, Dr. F. P. Thomas, and Thomas W. Long.

ELKS HOME. In 1911, the Benevolent and Protective Order of Elks constructed this lodge and boarding house on the southeast corner of Ninth and Bethel Streets. It was later converted into professional offices and is now the site of Water Street Place Apartments.

HOME OF R. L. THOMPSON. Robert L. "Bob" Thompson and his wife, Mamie, built this home on East Seventh Street at Gooch Alley, now St. Michael's Way, about 1916. It is the work of Thompson's superb craftsmanship and remains a fine example of the American Four Square style. The home currently serves as rectory for SS. Peter and Paul Roman Catholic Church.

Seven

GOVERNMENT AND COMMUNITY LIFE

Christian County Court House,
Hopkinsville, Ky.
"The Second Largest Tobacco Market
in the World."

TOBACCO LEAF. This image portrays the economic impact of the tobacco culture on Hopkinsville a century ago. The postcard claims that Hopkinsville is "The second largest tobacco market in the world." It features the Christian County Court House on a postcard published by S. H. Kress.

COURTHOUSE, C. 1900. The Christian County Court House is featured in this color-tinted postcard that shows the original cupola. A larger and more impressive cupola replaced this architectural feature in 1903. The mailer of the postcard attached a 1908 American Red Cross Christmas stamp to the face of the card.

CHRISTIAN COUNTY COURT HOUSE, C. 1906. The county seat of justice, the fourth on the site, was constructed between 1867 and 1869 after C.S.A. brigadier general Hylan B. Lyon of Eddyville, Kentucky, had burned its predecessor December 12, 1864. Steam heat was installed and the original cupola was replaced in 1903. The vaults were enlarged in 1918, and a remodeling process started in 1955. The removal of the second cupola in 1960 started the process of destroying the original architectural integrity of the landmark.

A 17060 Court House, Hopkinsville, Ky.

COURTHOUSE, C. 1906. A wintry day with the absence of leaves reveals the architectural details of this landmark. Tree trunks were boarded to protect them from wagon wheels and scuff marks inflicted by horses. The clerk's office building, located to the right of the courthouse, was the location of county records at the time the old courthouse was burned in 1864. The original city hall, with cupola containing the fire bell, is in view at extreme right.

CITY HALL.

HOPKINSVILLE, KY.

FIRE DEPARTMENT.

CITY BUILDINGS. S. H. Kress published this color card that features the fire department and city hall about 1915. City hall, located on the southwest corner of Fifth and Main Streets, was constructed in 1870 and torn down in 1927. The fire station was built in 1904–1905 and achieved nationwide attention when it burned in October 1924.

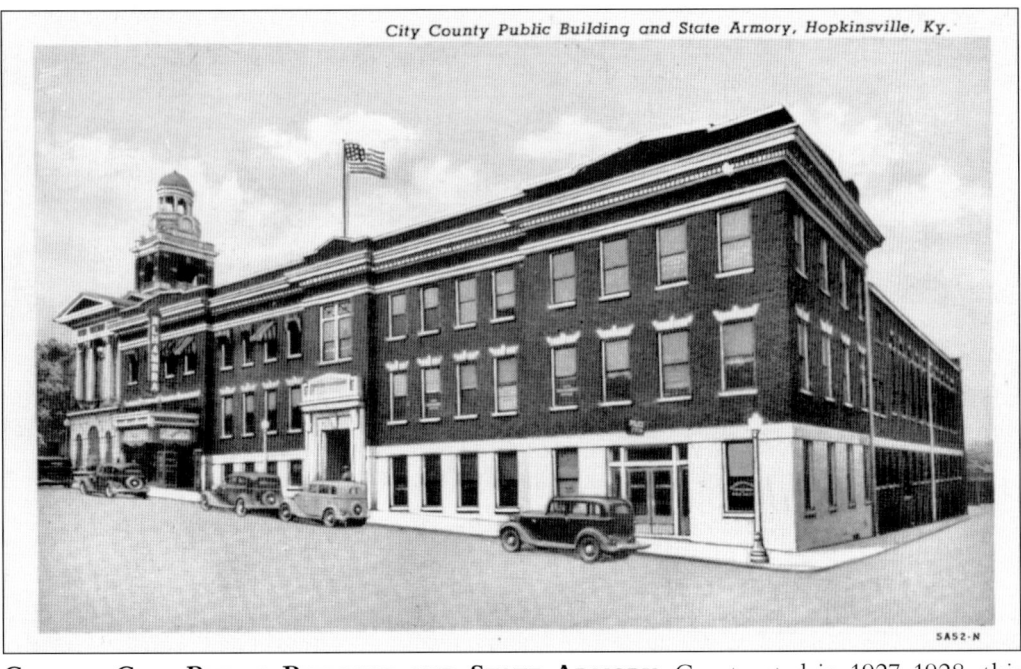

COUNTY-CITY PUBLIC BUILDING AND STATE ARMORY. Constructed in 1927–1928, this facility represented the first construction in Kentucky through joint city-county effort. Law offices, police station, state armory, and the Alhambra Theatre were the original occupants. The Alhambra Theatre was the first structure in Hopkinsville to be air-cooled (an early attempt at air conditioning). Evangelist Billy Sunday and cowboy Roy Rogers performed on its stage.

LACKEY MUNICIPAL CENTER. First and North Main is the location of Hopkinsville city administration offices. The facility, a part of the Dr. Frank H. Bassett Urban Renewal Project, was dedicated in 1964 and named in honor of former mayor F. Ernest "Dutch" Lackey.

U.S. POST OFFICE, C. 1915. Located on the southwest corner of Ninth and Liberty Streets, the former U.S. Post Office was constructed by the federal government in 1913–1914 and was in use as the Hopkinsville Post Office from 1915 to 1967. It later served as the United Services Organization (USO) Servicemen's Center. Since July 8, 1976, the building has housed the Pennyroyal Area Museum.

CARNEGIE PUBLIC LIBRARY. The Hopkinsville Library Company, founded in 1816, was one of the first west of the Allegheny Mountains. Hopkinsville Public Library opened in 1874. Clay Street Public Schools Library opened in 1882. Hopkinsville Library Association operated from 1896 until 1914. In 1913, a Carnegie Foundation grant allowed for the construction of the Carnegie Library. Located on the northeast corner of Eighth and Liberty Streets, the facility opened on October 1, 1914, and was in use until the library moved to its new location in December 1976.

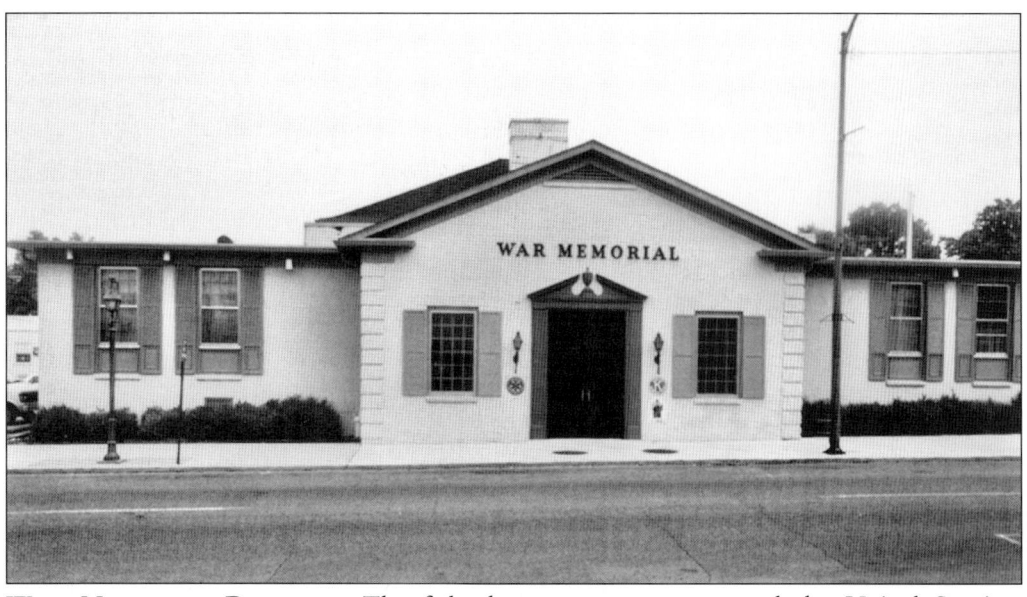

WAR MEMORIAL BUILDING. The federal government constructed the United Services Organization building on Virginia Street between Twelfth and Thirteenth Streets in 1943. The USO operated in the building from December 1943 until it closed in October 1947. The locally organized Living War Memorial Commission secured the building as a community center in 1948. The facility is dedicated to the memory of those men and women "who gave the last full measure of devotion."

CONFEDERATE MONUMENT. People, horses, and buggies gather before the Confederate Monument in Hopewell (now Riverside) Cemetery for observance of Confederate Memorial Day, one June 3 in the late 1890s. The monument honors the memory of 101 unknown Confederate soldiers who died in Hopkinsville during the winter of 1861–1862. It was a gift to the community by Confederate soldier John C. Latham Jr. It was dedicated on May 19, 1887.

CENTRAL FIRE STATION, C. 1920. This fire station was built on the north side of East Ninth Street between Liberty and Clay Streets in 1904–1905. The tower, which contained the town clock, was 85 feet high. This architectural gem fell as the town clock was striking midnight when fire consumed the structure in October 1924. A new fire station was constructed at the same location and operated until 1964. It is currently being restored and will serve as the Pennyroyal Area Transportation Museum.

FIRE HORSE POWER, C. 1908. Firefighters and police officers line up to display the town's fire horses in front of the station on East Ninth Street nearly a century ago. The horses were, from left to right, Clipper, George, Snowy, and Dixie. While some of the men pictured on this card are unidentified, police officer Abner W. Witherspoon stands at the far left, and firefighter John Lawson is the fourth man from the left.

LOCAL FIREMEN. These two unidentified Hopkinsville firefighters stand at attention as they show off their protective fire gear in front of the station on Ninth Street about 1910.

WATER WORKS DAM. L. L. Elgin, a local druggist, published this color postcard featuring the Water Works Dam located near Blue Lake on North Vine Street. Constructed in 1895, the dam created a pool that supplied the water for the city pumping station.

STAND PIPE AT WATER WORKS. The Hopkinsville Water Company built the first pumping station and stand pipe in 1895 and began operation on January 3, 1896. This water supply tank was constructed on Stand Pipe Hill near Gainesville Baptist Church off East First Street. This tank was demolished on December 17, 1974, and replaced by the present one.

HOPKINSVILLE SANITARIUM. Dr. Charles B. Petrie opened the first medical hospital at the northeast corner of Seventh and Clay Streets in November 1905. It was constructed in the front side yard of the Maj. S. R. Crumbaugh home (shown at left). James L. Long was the architect for the 60-by-40-foot building, which accommodated an operating room and 13 rooms for patients. The hospital closed in 1909.

HOPKINSVILLE HOSPITAL. In September 1912, eight Hopkinsville doctors opened the second medical hospital, located in the old Peter Postell House on the northwest corner of Fifth and Clay Streets. The doctors were J. E. Stone, F. Preston Thomas, R. F. McDaniel, F. M. Brown, J. Paul Keith, J. B. Jackson, Austin Bell, and J. Gant Gaither. The superintendent was Wanda M. Williams. The medical facility closed in 1914 with the opening of Jennie Stuart Memorial Hospital.

JENNIE STUART MEMORIAL HOSPITAL, C. 1935. A gift of $52,125 by Dr. Edward S. Stuart of Fairview between 1914 and 1922 established the hospital in memory of his wife, Mrs. Jane (Jennie) Vaughan Stuart. James S. Murphy of Louisville was the architect, and the contractor was Forbes Manufacturing Company. Built at a cost of $34,300, the 28-bed facility, located on West Seventeenth Street, was opened July 1, 1914.

JENNIE STUART MEMORIAL HOSPITAL, C. 1948. This side view of the hospital shows a back wing, which was added in the mid-1940s. There have been many more additions throughout the years. The name was changed to Jennie Stuart Medical Center in 1982. Note the incorrect spelling of the hospital name as it appears on this color postcard.

THE MOORE CLINIC, 5TH AND LIBERTY STS., HOPKINSVILLE, KY.

MOORE CLINIC. Bankie O. Moore, M.D., operated this clinic for African Americans from 1935 until 1953. It was located in the old rectory of Grace Episcopal Church on the northwest corner of Fifth and Liberty Streets.

BROOKS MEMORIAL HOSPITAL. Philip C. Brooks, M.D., built this stone hospital with his own hands on the southwest corner of Second and Virginia Streets. The facility opened July 9, 1944, and Dr. Brooks privately operated it until it closed in 1976.

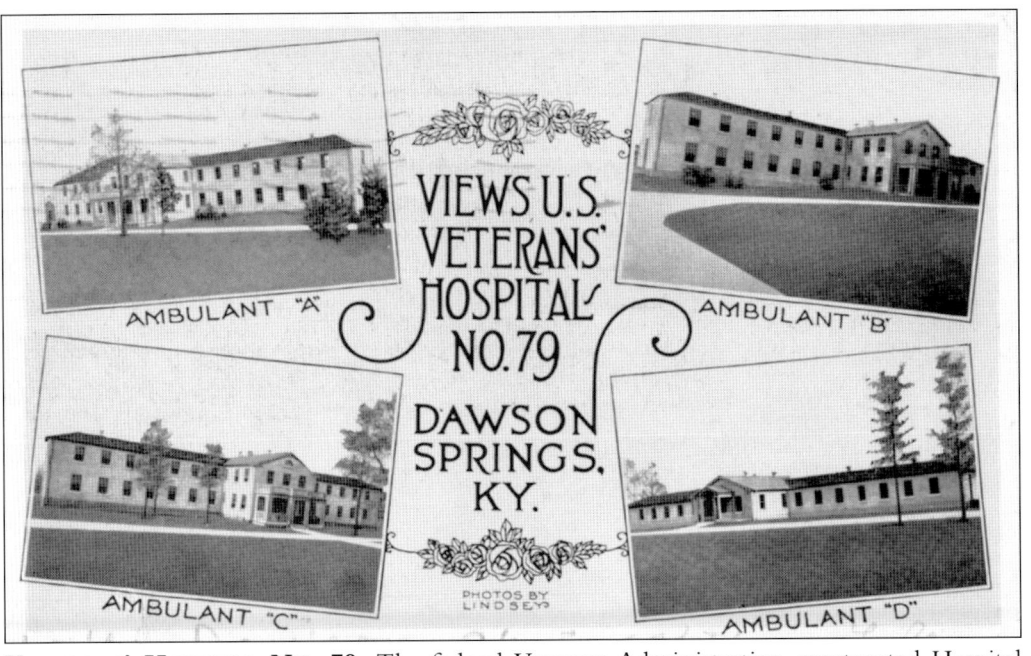

VETERANS' HOSPITAL NO. 79. The federal Veterans Administration constructed Hospital Number 79 between 1919 and 1921, near Dawson Springs. On dedication day, February 22, 1922, chartered passenger trains delivered hundreds of people to the site for the occasion. Hopkinsville florist Thomas L. Metcalfe provided a carnation for every lady present. This card provides a composite of four scenes at the facility.

V.A. HOSPITAL, OUTWOOD. In 1925, Hospital No. 79 was renamed "Outwood" when a government official remarked, "This facility is certainly located out in the woods." The hospital served as a tuberculosis sanatorium for World War I veterans. The campus contained 223 acres and 40 buildings. Operation of the hospital was transferred to the Commonwealth of Kentucky on September 1, 1962, for treatment of mentally challenged people.

WESTERN ASYLUM, *C.* **1900.** Western Kentucky Lunatic Asylum was established by the Kentucky legislature in 1848 on the 380-acre Spring Hill farm, formerly owned by the famous Methodist circuit rider Peter Cartwright. The main building at this Russellville Road facility was constructed 1848–1853 and opened September 1, 1854. Destroyed by fire November 30, 1860, it was rebuilt between 1861 and 1867. The institution became known as Western State Hospital in 1912, and it is still in operation today.

VIEWS OF WESTERN STATE HOSPITAL. Hopkinsville photographer W. R. Bowles produced this composite card of seven views of Western State Hospital about 1915. Therapy then consisted of work-related activity in handwork, farming, gardening, canning, and the operation of a dairy herd.

Eight

HOTELS AND MOTELS

HOTEL LATHAM AT NIGHT, C. 1915. Located on Virginia Street between Sixth and Seventh Streets, Hotel Latham was built by Hopkinsville Hotel Company in 1894. The cost for this elegant, three-story hotel was $104,000. The Italian Renaissance style incorporated the use of soft yellow brick and a red tile roof. It was named in honor of John C. Latham and opened January 3, 1895. Latham bought the hotel in 1898 for $15,000 when the company defaulted. William A. Wilgus, Capt. Lloyd W. Whitlow, and Albert D. Noe operated it. Noe bought the hotel in 1911, and his daughter, Nora Noe, managed the business for nearly 30 years. A spectacular fire on Sunday afternoon, August 4, 1940, destroyed the hotel.

LOBBY OF HOTEL LATHAM, C. 1905. Corinthian columns supporting a beamed ceiling presented a classic flair in this small-town hotel lobby. The open fireplace, out of the picture at left, and the grand stairway on the right were hallmarks in the architectural beauty of this structure. The hotel, with gas and electric lights, had 93 rooms and offered modern conveniences. Three overhead wheel-shaped skylights illuminated the terrazzo tile floor.

HOTEL LATHAM, C. 1935. The development of the Dixie Bee Line (U.S. Highway 41), a gravel road in 1926 with concrete surfacing in 1932, opened a tourist artery from Chicago to Jacksonville. Tourists' usage of Hotel Latham increased dramatically in that era. Famous visitors who "stopped over" at the Latham included Theodore Roosevelt, Williams Jennings Bryan, Charles Fairbanks, John Philip Sousa and his band, Ethel Barrymore, Andy Devine, and Alben W. Barkley.

94

REST OVER GUEST HOUSE — Miss Sophie M. Reeder, Hostess — HOPKINSVILLE, KY.

ON U. S. 41 — NORTH EDGE OF TOWN — Listed by DUNCAN HINES D-6709

REEDER'S REST OVER GUEST HOUSE. The 1930s and 1940s witnessed the popularity of rest overs, motel accommodations in private homes. Reeder's Rest Over was a grouping of four homes located on the east side of North Main Street. It was owned by Sophie M. Reeder (hostess) and her sister, Lureina Reeder, from 1948 until 1968 and was recommended by Duncan Hines. In 1976, the old house was moved to North Drive and is now the Homestead Restaurant.

ROCK HILL TOURIST CAMP ~ U.S. HIGHWAY 41 JUST NORTH of HOPKINSVILLE ~ KY.

ROCK HILL TOURIST CAMP. Rock Hill was in operation from about 1945 until 1954 on the west side of Madisonville Road (U.S. Highway 41 North). Harry Kelly, H. E. Noel, and Lawrence Cook operated it. Madisonville Road, north of town, and the Clarksville Pike (U.S. Highway 41 A), south of town, were the principal locations of motels in the era from 1940 until 1970.

LAKE'S COTTAGE INN. Lake's Cottage Inn was in business on the Clarksville Pike (U.S. Highway 41 A) between 1942 and 1946. Thomas F. and Flossie Lake operated the inn.

WADLINGTON ROCK MOTEL. Located on the east side of Madisonville Road, Wadlington Rock Motel was the longest running motel in Hopkinsville. W. Roy Wadlington opened the business about 1940, and it remained in operation until 1970. The arrival of the automobile brought edge-of-town sleeping accommodations often called tourist cabins, camps, courts, motor lodges, rest overs, inns, and motels.

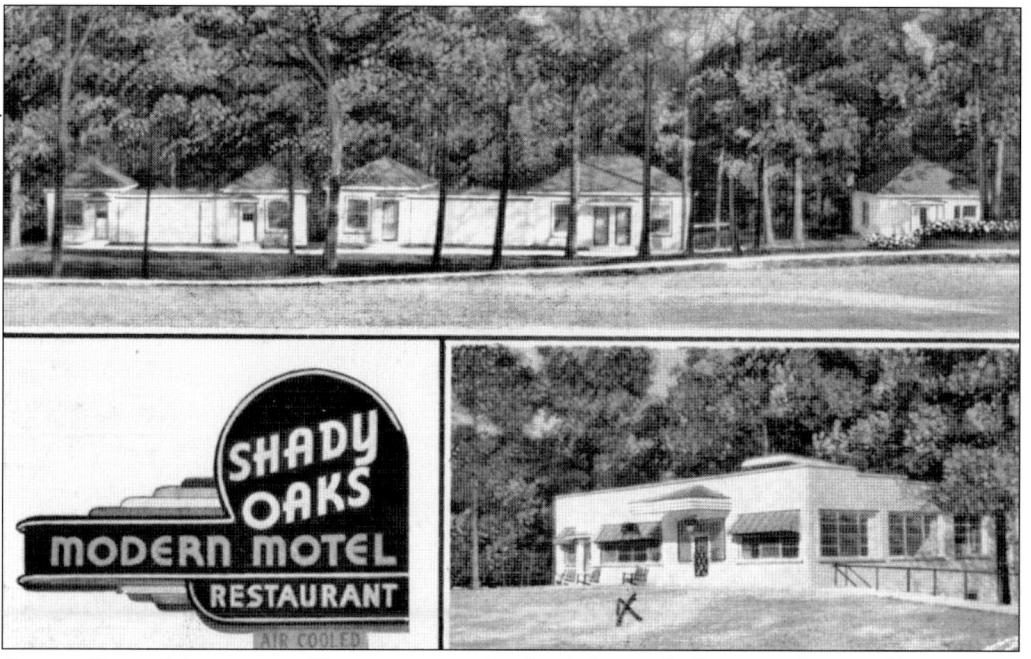

SHADY OAKS MOTEL AND RESTAURANT. Shady Oaks was built soon after World War II on Madisonville Road (U.S. Highway 41 North). It became a very popular tourist stop for fine food and pleasant accommodations. Roscoe Pyle owned the landmark when it burned on June 28, 1957. The motel section remains.

KING'S COURT MOTEL. This motel was built in the late 1940s and was operated by C. H. and Margaret King. It was located on the south side of Clarksville Pike (now Fort Campbell Boulevard) at Nelson Drive. Later owners included Gary Latham, W. J. Gallagher, and A. W. Whitmer.

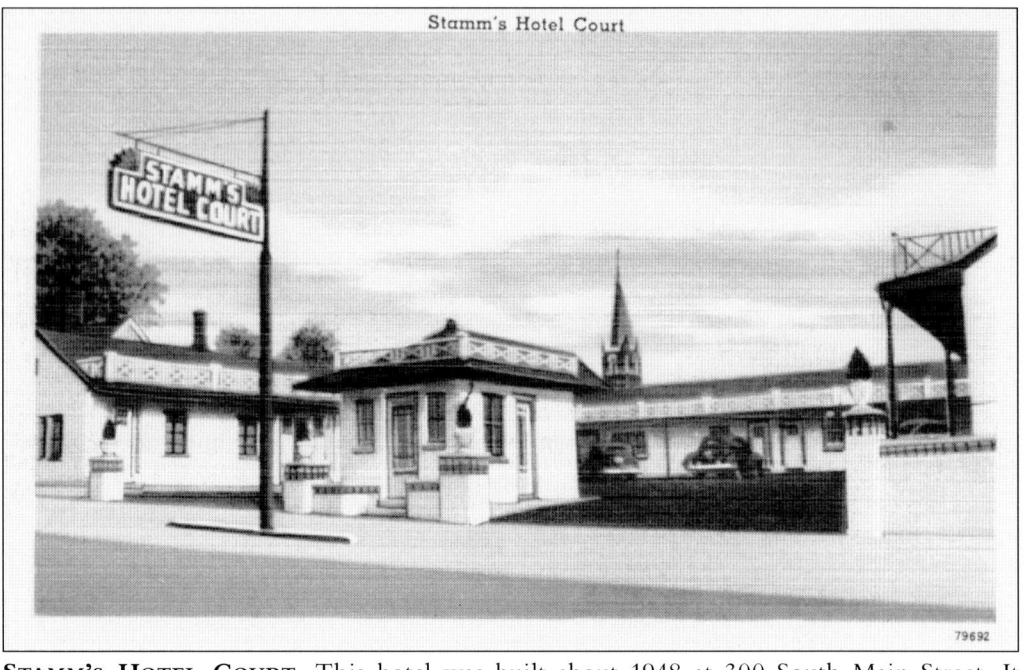

79692

STAMM'S HOTEL COURT. This hotel was built about 1948 at 300 South Main Street. It continues in operation today. Some of the previous operators were G. A. Stamm, Annilee Robertson, C. B. Gooch, R. J. Bailey, and Dougless Morris.

Y & G Motel, 1½ miles north on U.S. 41, Hopkinsville, Ky.

Y&G MOTEL. In 1950, Ellis L. Young and Herchel Grace built the Y&G Motel. It was located on the east side of Madisonville Road near present-day North Drive. Young bought Grace's interest, renaming the business Hopkinsville Plaza. Later Young built the Plaza restaurant, which became known as the Mustang Lounge.

LITTLE RIVER MOTEL
On U.S. 41 In City, Hopkinsville, Ky.

LITTLE RIVER MOTEL. This motel was built on the north bank of Little River and on the west side of North Main Street at Means Avenue about 1954. In operation today, it has been managed by D. C. and Fannie B. Young, R. E. Butt, S. B. and Hattie Stanfill, D. E. Whitmer, Claxton Finley, J. E. Mitchell, and Allen Whitmer.

JEFF DAVIS MOTEL
U. S. 41 — North City Limits
Hopkinsville, Ky.

JEFF DAVIS MOTEL. Located on the west side of Madisonville Road (U.S. Highway 41 North), across from Christian Quarries, this motel is still in operation. It was built about 1954 and was operated by J. W. Willard, C. A. Tygrett, Sam Curtley, Calvin M. Isbelle, Delos A. and Martha L. Welch, Mike Himber, and Hubert Cook.

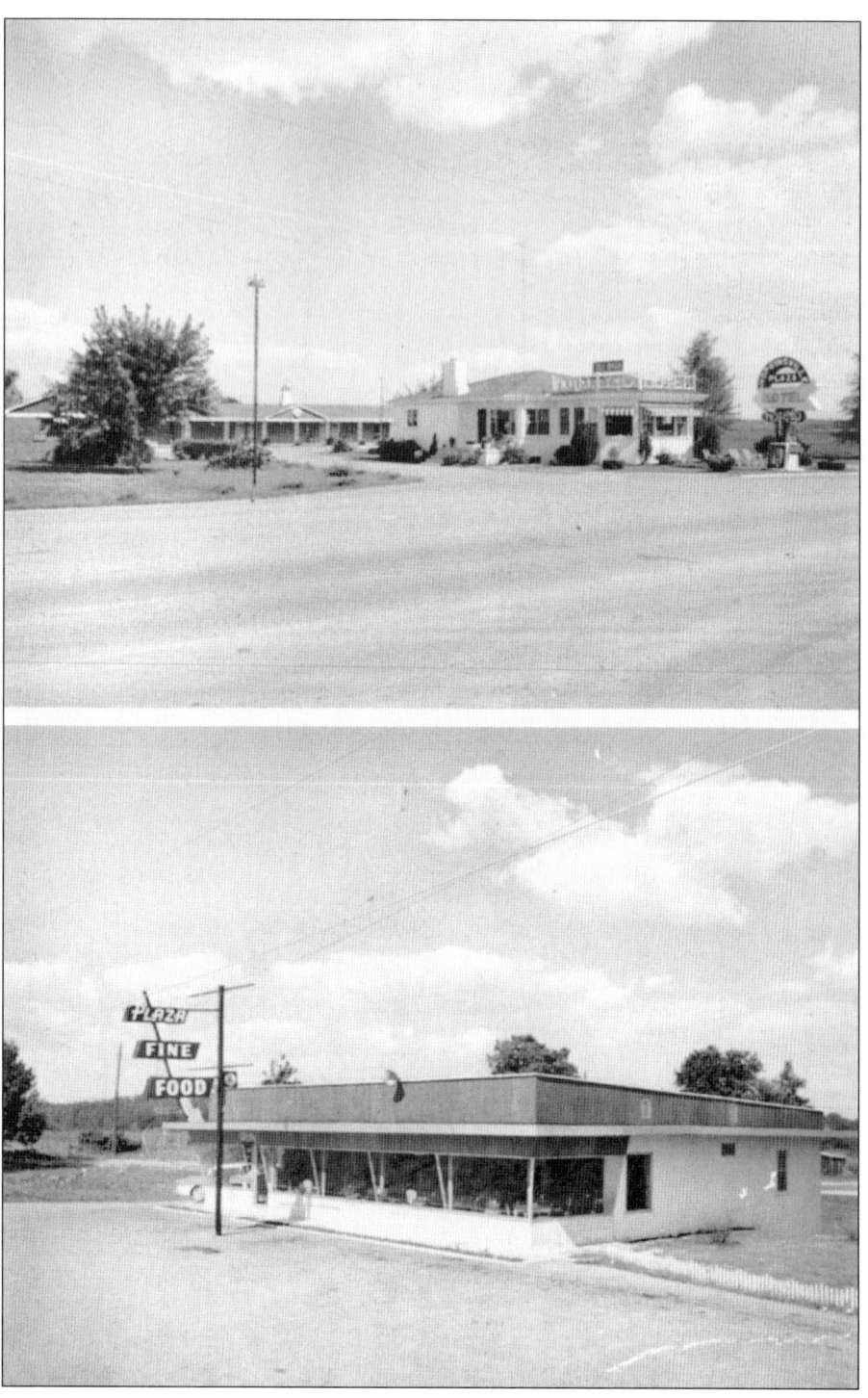

PLAZA FINE FOODS AND MOTEL. This restaurant/motel stood on the east side of Madisonville Road on the present site of the U.S. Smokeless Tobacco Company. It was opened about 1960 and was operated by Walter F. Whitson, A. M. Whitmer, and Clayton Finley. Fire destroyed this motel on November 20, 1969, with a loss estimated at $100,000.

COLONIAL MOTEL, C. 1962. Ellis L. and Virginia Young opened this 19-room motel, restaurant, and beauty parlor in 1962. The facility featured air-conditioned units and television, both novel attractions for that era. Located at 320 North Main Street, this accommodation for the traveling public was situated on U.S. Highway 41 North. Gysbert Oostlander and Gerald Evans later operated the motel. Victor Patel assumed its management about 1981.

IV'RY TOWER INN. Located at Fort Campbell Boulevard and Country Club Lane, the Iv'ry Tower Inn was built by Homer H. Holt and opened in 1964. It remained in operation until about 1989. Among its managers were H. H. Holt, J. E. Staunton, J. L. Dunkin, and Morgan Smith.

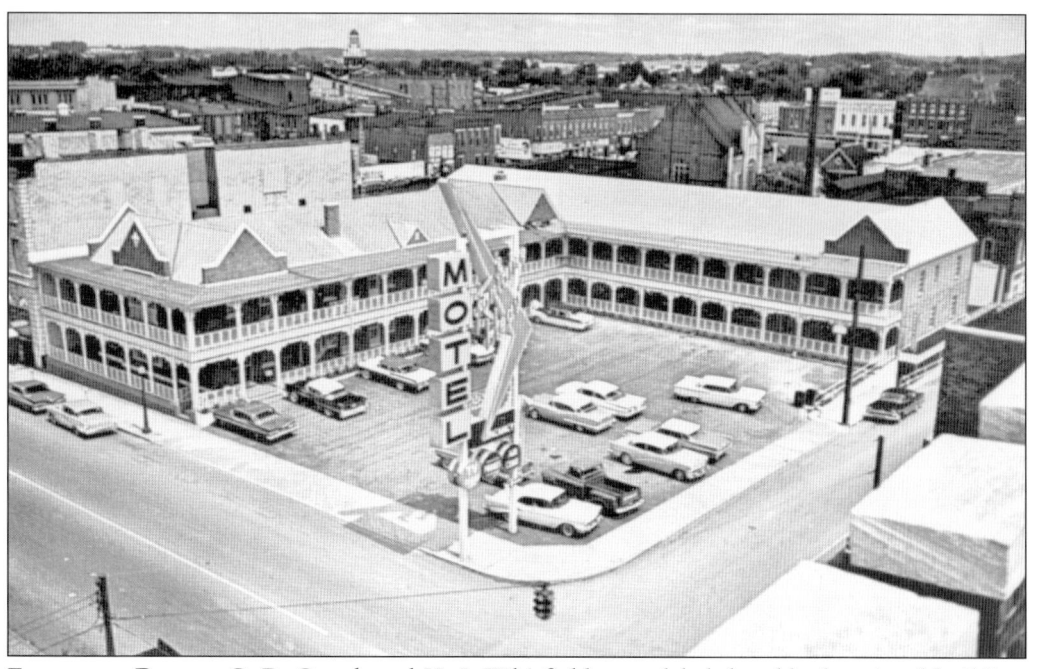

FONTAINE BLEAU. C. B. Gooch and H. J. Whitfield remodeled the old educational building of the Ninth Street Christian Church, added the back wing, and opened this motel in 1958. Located on the northwest corner of East Ninth and Liberty Streets, it was in operation until 1983. Operators included C. B. Gooch and Annilee O. Robertson.

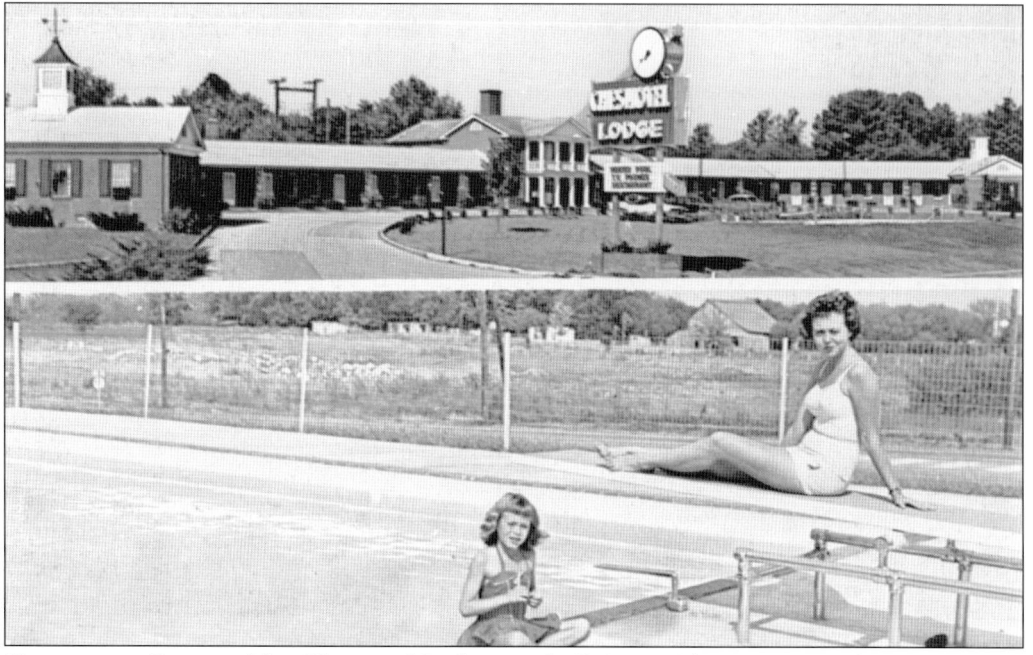

CHESMOTEL LODGE. The Chesmotel Lodge was built in 1950 by Henry C. Chesnut. Located at the corner of Fort Campbell Boulevard and Country Club Lane, it was one of the largest and most handsome of the local motels. It remained in operation until the late 1980s and was torn down in October 1993. Blockbuster Video and Taco Bell are located on the site today.

Nine

LEISURE TIME AND NOVELTY CARDS

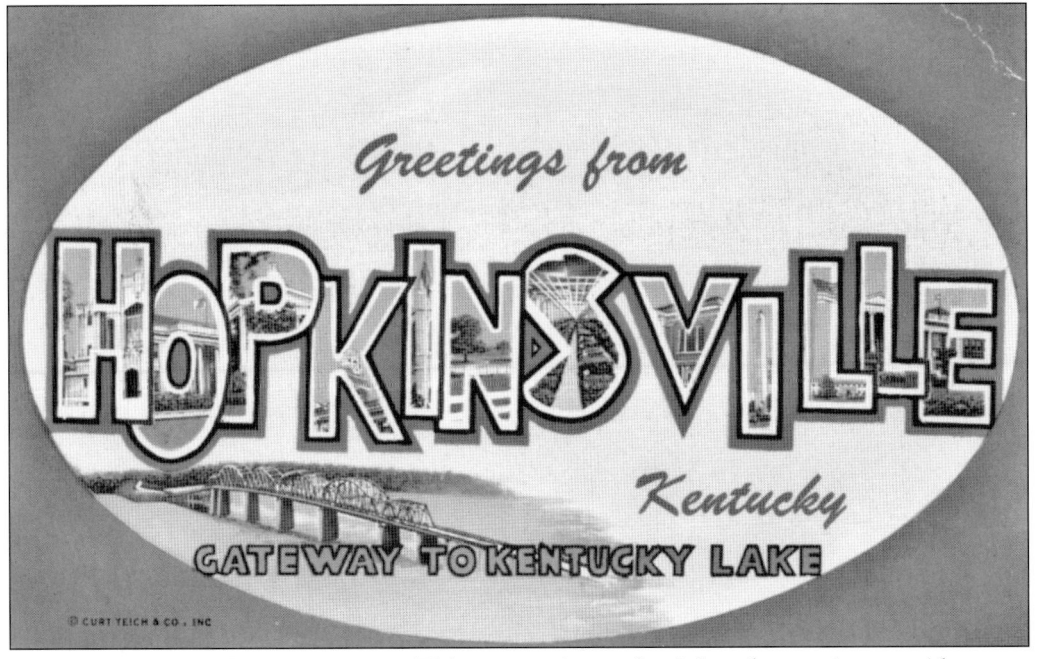

GREETINGS FROM HOPKINSVILLE. This composite card, giving the receiver a wide range of local views, was popular in the 1940s and 1950s: H–Methodist church, O–post office, P–Western State Hospital, K–courthouse, I–Baptist church, N–Ben Wood's Stock Farm, S–tobacco warehouse, V–public library, I–Jefferson Davis Monument, L–Fort Campbell, L–Bethel Woman's College, and E–high school.

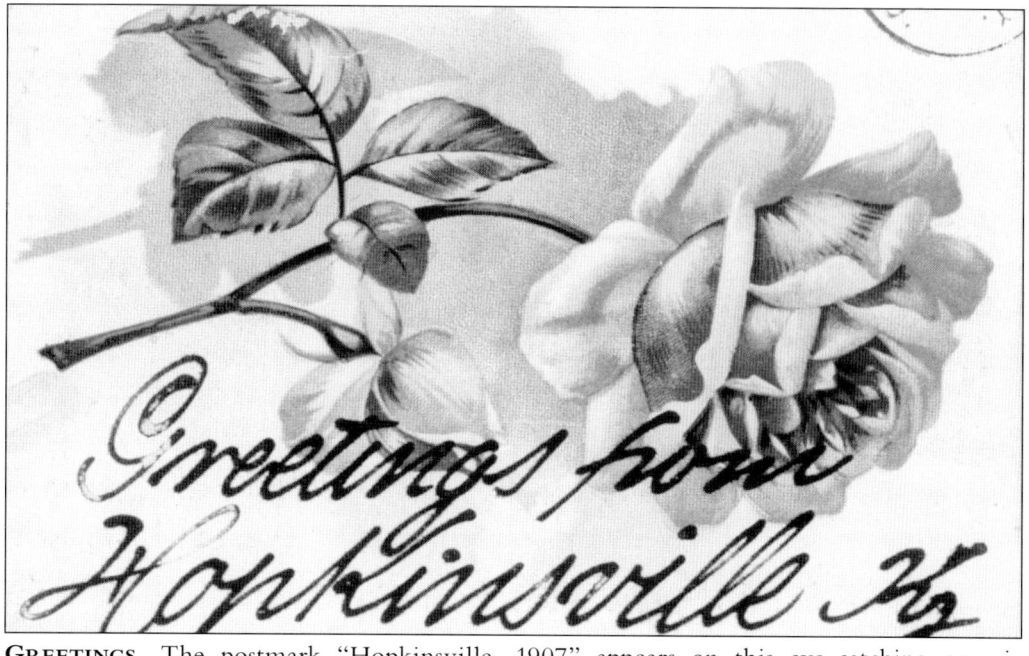

GREETINGS. The postmark "Hopkinsville, 1907" appears on this eye-catching generic postcard. The message from "M. G." to "Miss Ruby Smithson, Guthrie, Kentucky," contained a greeting. Many correspondents of the time exchanged postcards and some even developed their own code for communication.

NOVELTY CARD. Postcard producers and collectors exhibited a fancy for cartoon characters or stock photography with the community's name prominently displayed. Here a couple poses back to back in a trash container or a mailbox. This card was published in England and features Samforth's famous lovers, a pair frequently illustrated in the British press.

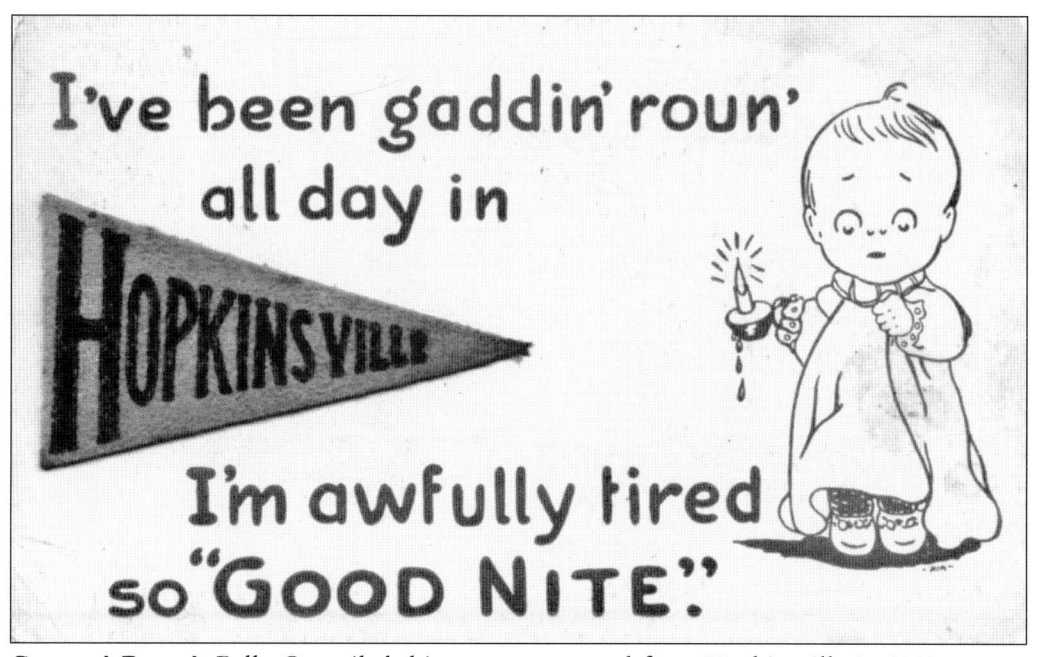

GADDIN' ROUN'. Belle C. mailed this cartoon postcard from Hopkinsville in 1919 to Mrs. Harry Nixon in New Iberia, Louisiana. Belle C. writes, "I have been Christmas shopping all day and my feet hurt. Eat all the oysters you can and think of me."

"KENTUCKIANS." Good whiskey, fast horses, and beautiful women are the features of this card, published by Edgar Cayce and Company, Bowling Green, Kentucky, in 1906.

BAYING AT THE MOON. Another form of novelty cards were those made of leather. This version of a lone jack baying at the moon was addressed to a Madisonville, Kentucky, woman. It was postmarked "Hopkinsville, 1 November" and bore a 2¢ Thomas Jefferson stamp.

A NOTE FROM HOPKINSVILLE. This card is another example of those in popular exchange a century ago. The coming of the automobile in the first decade of the 20th century provided a timely theme in novelty postcards that featured colorful flowers and a note from the named town.

JONES' MILL. Thirteen miles southwest of Hopkinsville, on Little River at the Christian-Trigg County line, stood a popular picnic site at Jones' Mill. The milldam provided an excellent swimming hole for boys and young men in the area a century ago.

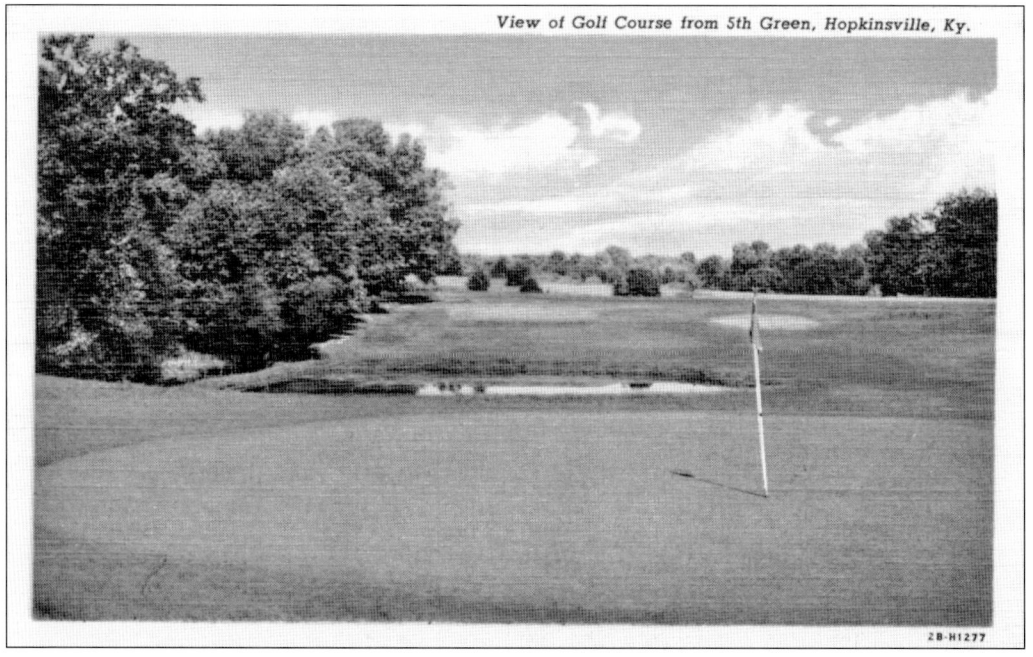

HOPKINSVILLE GOLF COURSE. This view of the golf course on County Club Lane, from the fifth green, features a scene of unspoiled beauty. The Hopkinsville Golf and Country Club, the first established in the community, opened in 1916. It is the namesake of Country Club Lane, a heavily traveled thoroughfare from Fort Campbell Boulevard to Canton Pike.

ODD FELLOWS BUILDING. One of the popular fraternal orders in Hopkinsville for 150 years was the Green River Lodge No. 54, Independent Order of Odd Fellows. The lodge was formed in 1848, and in 1902, they built this landmark located on the northeast corner of Ninth and Virginia Streets. The lodge room was located on the third floor, offices on the second, and retail businesses on the first floor.

ELKS CLUB INTERIOR. Pearl City Lodge No. 545 Benevolent and Protective Order of Elks was organized in Hopkinsville in 1900. The members constructed an Elks Hall on Ninth Street. This interior image illustrates the lounge and exhibits the furnishings of a poolroom over a century ago. The hall was destroyed by fire on March 31, 1911, along with W. A. Davis Confectionary and Ficken and Atkins Barber Shop.

MOVIE THEATERS, C. 1913. These night views proudly advertise the two local movie theaters in Hopkinsville at that time. Both were located on East Ninth Street between Main and Virginia Streets. The Princess opened in 1911, advertised 600 seats, and was the site of the first talking picture shown in Hopkinsville in 1928. The Rex, directly across the street, opened in 1912, became the Kentucky Theatre in 1937, and closed in 1956.

RACE TRACK AT FAIRGROUNDS. This rare postcard of the Pennyroyal Fairgrounds about 1918 features the grandstand and racetrack. This fair, one of several in the county's history, had a run from 1913 to 1926 and was located on the west side of Palmyra (now South Virginia Street) in the Pardue Lane vicinity.

VIRGINIA PARK. Traveling along Ninth Street presents this view of Virginia Park. The block was the site of the John C. Latham homestead, bequeathed to the city in 1909 for the development of this park. The stone bandstand has long been the platform for revivals, political rallies, Easter egg hunts, and band concerts. The park was named in memory of Latham's mother, Virginia Glass Latham.

Scene in Virginia Street Park. Hopkinsville, Ky.—12

SCENE IN VIRGINIA PARK. Virginia Park, located on Campbell Street between Seventh and Ninth Streets, has been a center for Hopkinsville social life for many years. When John C. Latham established the park in 1909, funds were provided for the erection of statues throughout the grounds. Time and vandalism have caused all of them to be removed. Note the incorrect caption on this postcard.

THE LAKE. The Hopkinsville Water System, established in 1895, constructed a lake for the town water supply on Antioch Road off Greenville Road. The lake was named for the local president of the City Bank and Trust Company, William T. Tandy. A clubhouse was built near the lake, and it was the home of the Hopkinsville Hunting and Fishing Club until 2004. This landmark was also the site of the annual Ferrell's Boys Reunion from 1915 to 1957.

Lake Tandy, Hopkinsville, Ky.—19

LAKE TANDY. This rare postcard features a view across Lake Tandy, a major water reservoir for the city of Hopkinsville since 1895.

Christian County Natural Bridge, near Hopkinsville, Ky. Copyright by Bacon & Prowse 2392

NATURAL BRIDGE. About 20 miles northeast of Hopkinsville, in the community of Apex, stands this natural landmark, a popular spot for picnic goers and lovers for 200 years.

"Prospect Point," Pilot Rock, near Hopkinsville, Ky. 8871

PILOT ROCK. The best-known natural landmark in the area is Pilot Rock, located just across the line in Todd County. This postcard dates from *c.* 1905 and portrays the rock void of the timber and undergrowth now obscuring an extensive view. Native Americans and later early settlers used the rock as a guide as they made their way westward along Highland Lick Road across north Christian County.

Ten

CHRISTIAN COUNTY

Greetings from CASKY, Kentucky

GREETINGS FROM CASKY. This generic card, though it portrays a nondescript scene, is nevertheless very rare. Casky was established as a stop on the Louisville and Nashville Railroad in 1867. The community had two stores, two churches, the railroad station, and a Grange Hall.

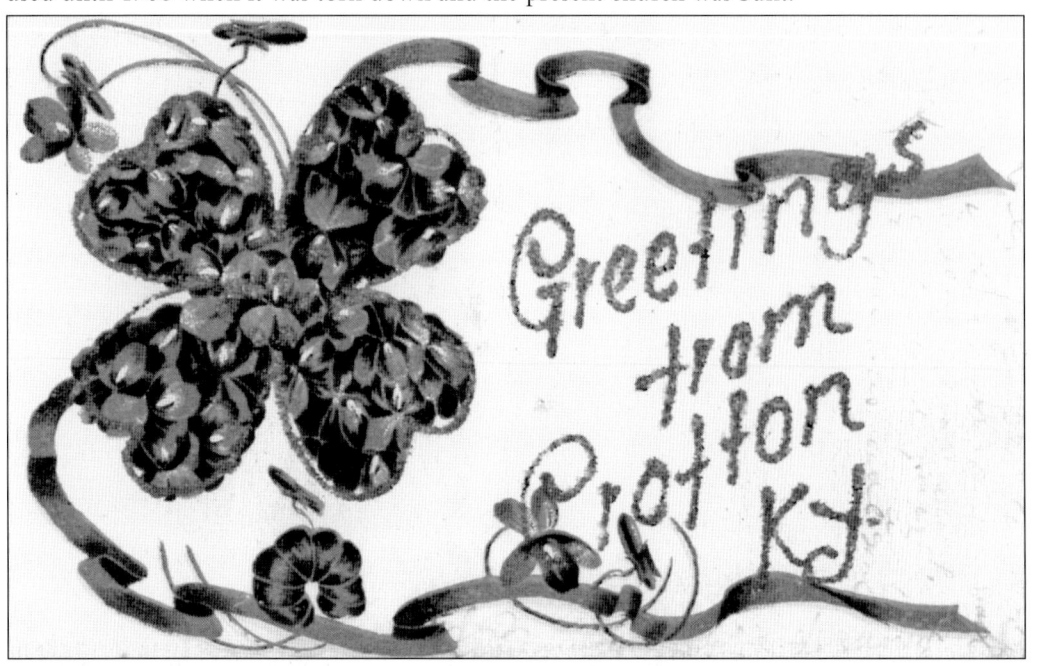

CASKY BAPTIST CHURCH. This church was organized 1886, and the building pictured was used until 1968 when it was torn down and the present church was built.

GREETINGS FROM CROFTON, KENTUCKY. This generic but most-attractive novelty card, featuring a four-leaf clover, was mailed to Pearl Overby from Hannibal Croft about 1912. It advertises a town established in 1869, named for James E. Croft, owner of the land in the area, and "put on the map" with the building of the L&N Railroad.

L&N Railroad Depot. The Crofton L&N Railroad station, pictured here *c.* 1920, was the meeting point for Crofton area people and the pick-up place for mail-order goods. Passenger service ended with the final run in February 1955, and the station was torn down in May 1959.

Crofton Hotel, *c.* 1920. This hotel/boarding house was constructed in 1906 after fire destroyed its predecessor on November 6, 1905. It remained in operation until 1959; it is still standing.

CROFTON GRADE AND HIGH SCHOOL, C. 1920. The pride of Crofton was constructed in 1917 at a cost of $30,000. It was destroyed by fire May 26, 1924. A duplicate building was constructed on the site that same year, and it burned down on January 6, 1951.

BUSINESS STREET, C. 1920. This postcard depicts the business district of Crofton, located on the east side of the railroad tracks, as it looked during the era of World War I. Subsequent fires have destroyed most of the buildings in this view. Note the Burkholder Mill on the right.

DOWN MEMORY LANE. A vintage automobile makes its way down a dirt street in Crofton as it plods along with memories of the past and hopes for the future.

FAIRVIEW SCHOOL. The pride of the Fairview community was the new consolidated school built across the road from the Jefferson Davis Monument early in the 20th century. For a time, the facility provided grades 1 through 12. In the 1920s, it was consolidated into the Pembroke School.

BETHEL BAPTIST CHURCH. This church was built on the site of the birthplace of Confederate president Jefferson Davis. The former president was an honored guest at the dedication on November 19, 1886, and he presented the church a silver communion service. Lightning struck the building on August 23, 1900, and it was destroyed. The structure was rebuilt within the original walls; it still survives a century later.

JEFFERSON DAVIS BIRTHPLACE. This 1898 card features a drawing by Charles O. Prowse of Wayfarers Rest, the log home in which Confederate president Jefferson Davis was born on June 3, 1808, at Fairview, Kentucky. The home was torn down in 1886 to make way for Bethel Baptist Church, which still stands on the site 120 years later.

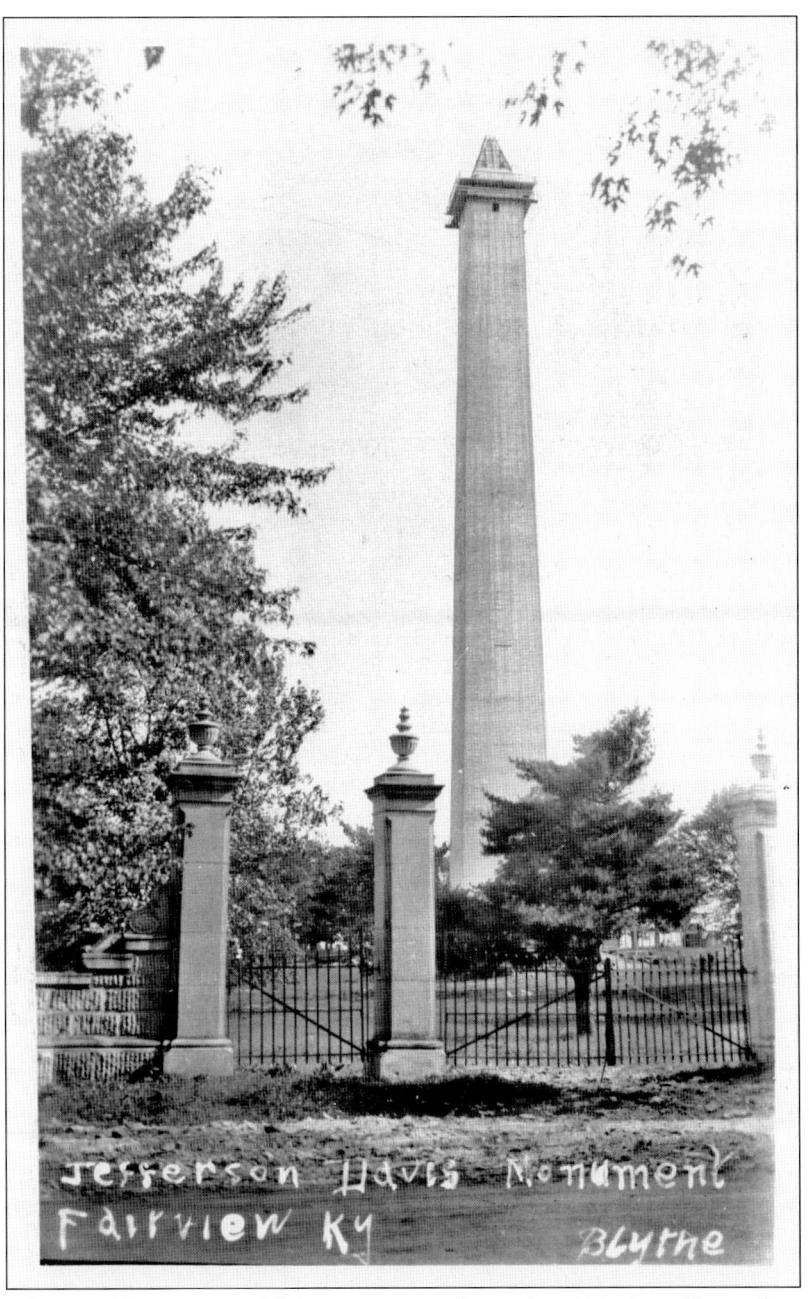

Jefferson Davis Monument
Fairview Ky
Blythe

JEFFERSON DAVIS MONUMENT. This monument, located at Fairview, Kentucky, marks the location of the birthplace of Jefferson Davis (1808–1889), West Point graduate, U.S. senator, secretary of war, and president of the Confederate States of America. The United Daughters of the Confederacy and the Confederate Veterans, motivated by the Orphan Brigade, marked the occasion of the centennial anniversary of his birth with plans for a park. Later these same groups raised $200,000 and, across the span of seven years, constructed a 351-foot cast concrete obelisk in the park. At the time of construction, it was the tallest cast concrete structure in the United States. No serious injuries were incurred during the construction. This real-photo card, made by Hopkinsville druggist Max J. Blythe, shows the monument on dedication day, June 7, 1924.

AERIAL VIEW OF MONUMENT. The monument at Fairview presents an interesting view from the air in the 1960s. Contractor George R. Grigg directed a force of laborers who built the structure using wooden frame forms, which were raised a level of about 10 feet per move. Jefferson Davis's birthday has been annually observed on June 3, with public speeches, military weaponry demonstrations, a Miss Confederacy beauty pageant, and a barbecue dinner.

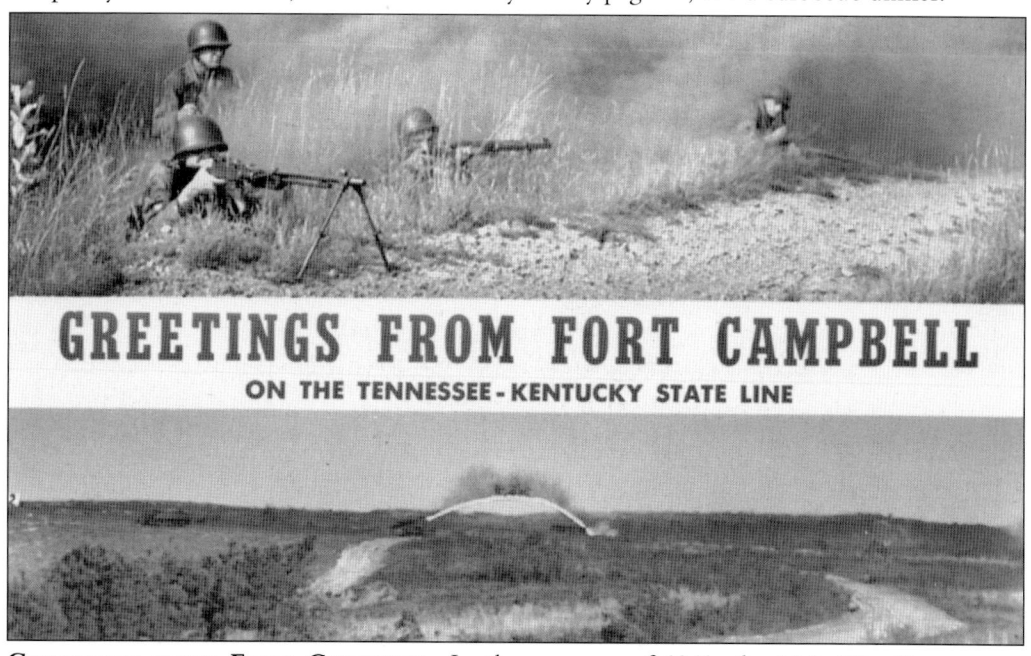

GREETINGS FROM FORT CAMPBELL. In the summer of 1941, the U.S. War Department selected a site for the establishment of a military base for the training of armored divisions. The camp, named for the last Whig governor of Tennessee and Mexican War hero Gen. William Bowen Campbell, was activated September 1942. The facility became a permanent base in 1950, hence the name Fort Campbell.

120

1C-H617

HEADQUARTERS BUILDING. The commanding general's headquarters, a two-story, frame, weather-boarded building, was constructed in 1941–1942. It remains the headquarters building over 60 years later.

Camp Campbell Field House, Camp Campbell, Ky.–Tenn.

2B-H1267

CAMP CAMPBELL FIELD HOUSE. This color card bears the caption "Camp Campbell, Ky.– Tenn.," and is the only known U.S. military base whose post office designation included two states. Postcards with the "Ky.-Tenn." designation are rare. Modern buildings have replaced most of the World War II–era structures.

SNAP SHOT. This rare, generic postcard of LaFayette, Kentucky, features two women posing behind a tree. The town of LaFayette, named for the French general Marquis de LaFayette, was incorporated March 1, 1836. The post office was established a year before.

GREETINGS FROM LAFAYETTE, KY. A winter scene is depicted on this *c.* 1915 generic card from LaFayette, Kentucky.

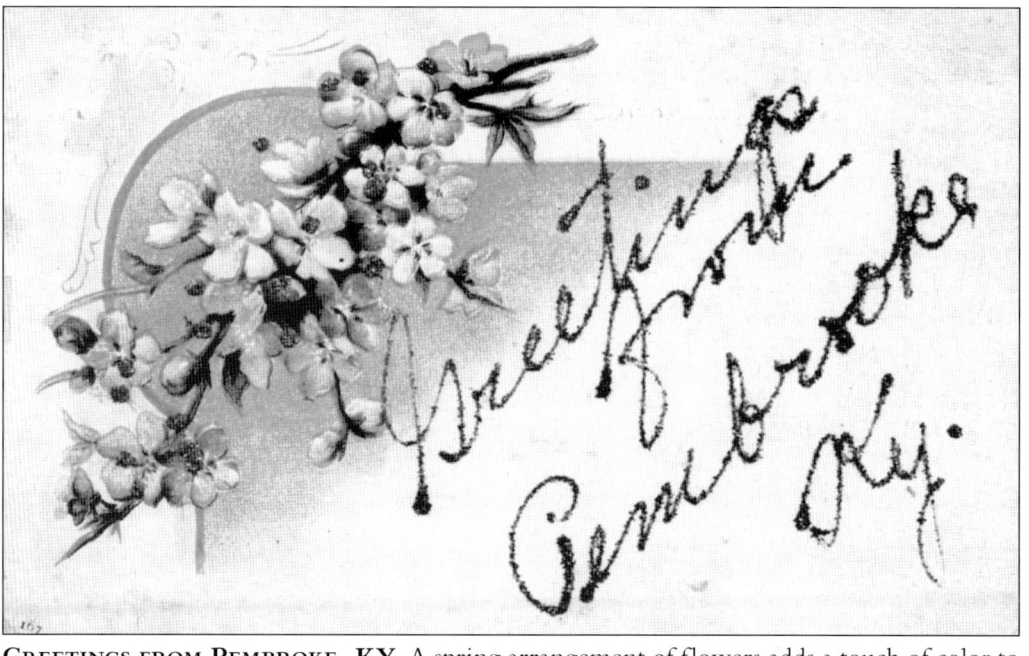

GREETINGS FROM PEMBROKE, KY. A spring arrangement of flowers adds a touch of color to this generic card printed *c.* 1912. The town of Pembroke received a post office designation on September 9, 1836, and incorporated March 6, 1869.

CHRISTIAN COUNTY HORSE SHOW. Pembroke, Kentucky, was the scene of very popular annual horse shows. The availability of an electric lighting system made the nighttime shows a magnet for large crowds. This very rare nighttime card shows a portion of the track and infield. A group of young people appears to be gathered at right, probably to sing to the crowd. The first show was conducted in September 1904 and continued annually for nearly 10 years.

MAIN STREET LOOKING NORTH, PEMBROKE, KY. This view of downtown Pembroke looking north across the L&N Railroad tracks was mailed to Miss Lizzie Alexander of Edna, Texas, in January 1910. The message indicates the arrival of more snow and the fact that young people were busy playing "old maid." The Farmers and Merchants Bank is shown at left with the Bank of Pembroke at right.

"OLD BETHEL" BAPTIST CHURCH NEAR PEMBROKE, KY. NEARLY 100 YEARS OLD.

OLD BETHEL. Old Bethel Baptist Church, located north of Pembroke, was nearly 100 years old when this postcard scene was snapped about 1910. The church was organized in 1816, and this brick structure, with its slave gallery for African American members, was constructed about 1818. The congregation divided peacefully in 1886 when several members established the Pembroke Baptist Church. The remaining members built Bethel Baptist Church in Fairview. The Old Bethel Church fell into ruins in the 1940s.

Lodge at Pennyrile State Park
Dawson Springs, Ky.

LODGE AT PENNYRILE STATE PARK. In 1930, as part of the Land Use and Resettlement Program, the Division of Forestry acquired leases on land in Christian, Hopkins, and Caldwell Counties, which became the Pennyrile State Forest. These leases were sustained until 1954, when the property was deeded by the federal government to the Commonwealth of Kentucky. Of the approximately 15,000 acres in the forest, 450 acres were developed into the Pennyrile State Resort Park

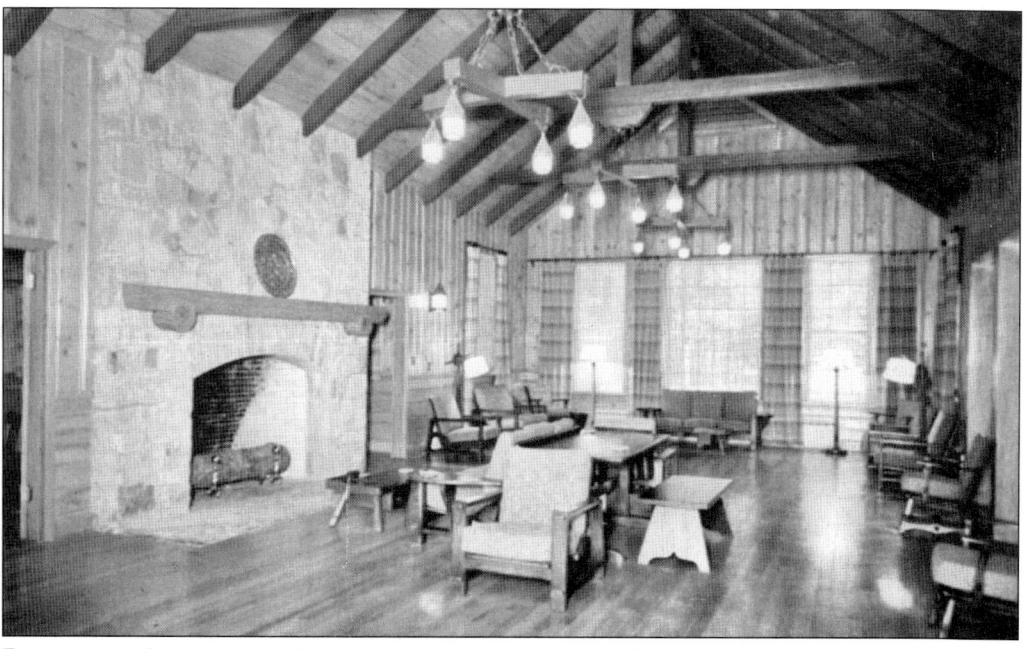

PENNYRILE STATE PARK LODGE LOUNGE. In the late 1940s, the park concession stand was enlarged into a lodge with 24 rooms. A nine-hole golf course, recently expanded to 18 holes, was developed in the south end of the park. The lounge, shown in this photograph, retains the interior decorations of the era in which it was built.

BATHING BEACH, PENNYRILE FOREST PARK
DAWSON SPRINGS, KY.

BATHING BEACH AND DIVING PLATFORM. The building of a dam on Thompson's Creek created the lake at Pennyrile State Park. This black-and-white card shows the bathing beach in the mid-1940s, an era in which many young people learned to swim by jumping off the diving platform.

Bathing Beach, Pennyrile Forest State Park, Ky.

BATHING BEACH. In the 1950s and 1960s, the beach and swimming area at Pennyrile State Park was an immensely popular gathering place for people of all ages within a 100-mile radius. The park offered everything for a complete vacation including modern and rustic cabins, a dining room, beach and swimming area, and paddleboats.

GREETINGS FROM SINKING FORK, KY. Red roses offered greetings from Sinking Fork, Kentucky, in this generic card a century ago. Sinking Fork, located on Princeton Road northwest of Hopkinsville, is one of the oldest settled communities in the county. It contains three churches, McCarroll Hill Baptist Church, Sinking Fork Baptist Church, and Sinking Fork Christian Church.

WOOD AND HILL GENERAL STORE. The general store at Sinking Fork was typical of many country stores throughout the county. Calico, crackers, and cultivators were available along with a coal-fired stove for wintertime conversation and a front porch for summertime gossip. The store was also the site of a post office from 1864 until 1910.

ACROSS AMERICA, PEOPLE ARE DISCOVERING SOMETHING WONDERFUL. *THEIR HERITAGE.*

Arcadia Publishing is the leading local history publisher in the United States. With more than 3,000 titles in print and hundreds of new titles released every year, Arcadia has extensive specialized experience chronicling the history of communities and celebrating America's hidden stories, bringing to life the people, places, and events from the past. To discover the history of other communities across the nation, please visit:

www.arcadiapublishing.com

Customized search tools allow you to find regional history books about the town where you grew up, the cities where your friends and family live, the town where your parents met, or even that retirement spot you've been dreaming about.

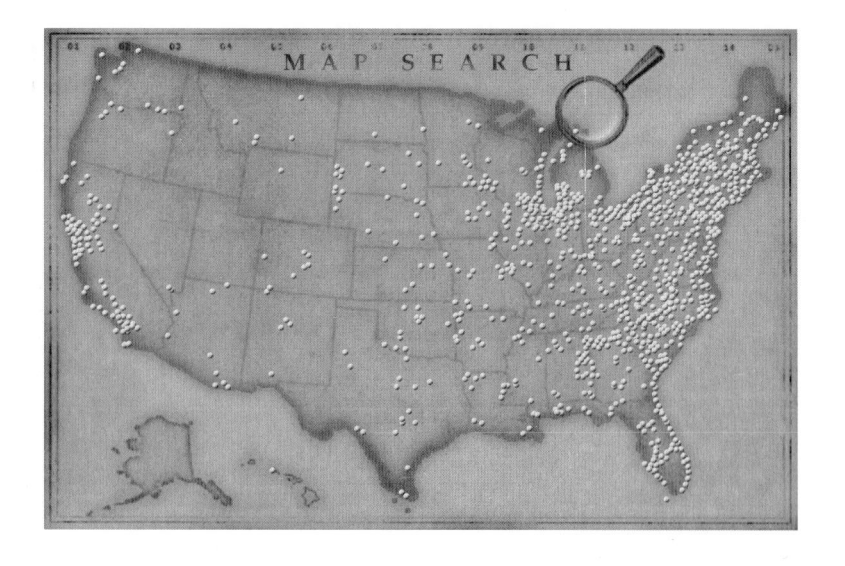